Christine L. Sundt
Architecture and Allied Arts Library
Visual Resources Collection
University of Oregon

Dr. Helen R. Tibbo
School of Information and Library Science
University of North Carolina at Chapel Hill

Susanne Warren
Lanzi/Warren Associates

Getty Information Institute

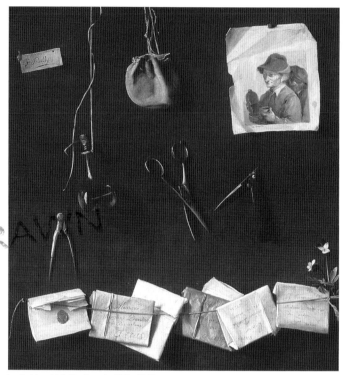

Cover image: Louis Léopold Boilly, French, 1761–1845
Trompe l'oeil. Oil on canvas, 28 $^9/_{16}$ × 23 $^{13}/_{16}$ inches
Sterling and Francine Clark Art Institute, Williamstown, Massachusetts

The URLs cited in this publication
were current at press time, but are
subject to change. For up-to-date
URLs, please visit the Web version of
this publication at http://www.gii.
getty.edu/intro_vocabularies/

Design by Hespenheide Design

Library of Congress Cataloging-in-
Publication Data
Lanzi, Elisa
Introduction to vocabularies : a
 guide to enhancing access to cul-
 tural heritage information / Elisa
Lanzi ; contributing editors,
Howard Besser . . . [et al.].
 p. cm.
 Includes bibliographical
 references (p.).
 ISBN 0-89236-544-7
 1. Subject headings—Cultural
property. I. Besser, Howard.
II. Getty Information Institute.
III. Title.
Z695.1.C85L36 1998
025.4′9—dc21 98-38514
 CIP

Acknowledgments

Special thanks to Patricia Young,
Head of the Vocabulary Program
of the Getty Information
Institute, for her support
and guidance on this project.
Nancy Bryan and Sheila Carey of
the Getty Information Institute
were instrumental in transform-
ing a complex manuscript into a
print publication.

Image credits:

p. 5 The J. Paul Getty Museum

p. 15 Art and Artifacts Division,
 Schomburg Center for
 Research in Black Culture,
 New York Public Library
 (Aston, Lenox and Tilden
 Foundation)

p. 31 Glasgow School of Art,
 Glasgow, Scotland

Contents

Foreword

Historically, the physical form of cultural materials has dictated where those materials reside: library, archive, museum, slide collection. As a result, each of the disciplines managing the sources of a particular kind of information has developed its own standards, guidelines, and terminology for documentation. However, with the emergence of global networks and the increasing demand for integrated access across disciplines, the development of more robust search tools has become imperative.

The Getty Information Institute has long recognized the importance of structured vocabularies for the description and indexing of cultural heritage materials. The *Art & Architecture Thesaurus* (AAT), the *Union List of Artist Names* (ULAN), and the *Getty Thesaurus of Geographic Names* (TGN) constitute powerful cataloging tools as well as knowledge navigators—semantic "maps" to help users find meaningful paths amid the vast range of resources now available on electronic networks. As tools, they can be used to provide an intellectual bridge connecting disparate cultural heritage materials no matter where they reside or how they have been described.

Introduction to Vocabularies: Enhancing Access to Cultural Heritage Information is another volume in our *Introduction to . . .* series aimed at the needs of those who create and disseminate cultural heritage information resources. It is our hope that the use of common standards and carefully structured terminology resources will make it possible to provide deep, multidisciplinary, contextual access to cultural heritage information worldwide.

Eleanor Fink
Director
Getty Information Institute

Introduction

Networked environments, such as the World Wide Web, present opportunities and challenges for the cultural heritage community: opportunities to share our rich information resources more widely, to educate, and to seek new audiences; and challenges to preserve the invaluable points of view represented by unique collections and reflected by divergent documentation practices in museums, libraries, archives, and image collections. Vocabularies provide the intellectual bridge across these communities; together with other data standards, they improve access when used in documentation practice and as search assistants in databases.

The idea for this publication was introduced at the Cultural Heritage Documentation and Education Focus Group Meeting, convened by the Getty Information Institute in Baltimore on October 18 and 19, 1996. At that meeting a group of eighteen educators and practitioners (including the author and contributing editors) from the archives, library, museum, and visual resources communities met to discuss new directions in the training of workers who provide access to cultural heritage resources. The group concluded that there was a pressing need for introductory materials that explained, demonstrated, and advocated the use of vocabularies in cultural heritage documentation. It was recommended that these materials be widely accessible (both Web- and print-based) and directed toward several key constituencies: students, practitioners, educators, and administrators.

Introduction to Vocabularies: Enhancing Access to Cultural Heritage Information is designed to provide you with a basic understanding of the benefits of using controlled vocabularies in cultural heritage information contexts. To assist you in utilizing vocabularies effectively, this publication will:

- demonstrate the benefits of using vocabularies.
- teach you how to use vocabularies to improve access to your cultural heritage information.

- guide you in making informed decisions about the application of vocabularies in both your local and networked environments.
- introduce you to the Getty Information Institute vocabularies: the *Art & Architecture Thesaurus,* the *Union List of Artist Names,* and the *Getty Thesaurus of Geographic Names.*

The publication's nucleus is a six-chapter study guide on the topic of vocabularies. Presenting the topic in the context of the related issues of documentation, standards, and access, the discussions use numerous examples and illustrations to emphasize how theory is applied to practice. You can read these six chapters in sequence or in the order of your specific interest. The Readings section, keyed to each chapter, provides direction for further study in cultural heritage, documentation, standards, and vocabularies. The other appendices offer additional support in the form of recommended tools and a list of acronyms and abbreviations.

Trying to address the needs of multiple audiences within a single publication (as mandated in Baltimore) has been a challenge—and an opportunity. With that in mind, I would like to point out the relevance of this publication for specific audiences:

- Practitioners (catalogers, archivists, librarians, visual resources specialists, collection managers, registrars) will find that this publication can provide a helpful overview of documentation practice across different communities, and that the examples in Chapter 6 are particularly relevant. The Tools section supplies a list of tools for applying vocabularies in everyday practice.
- Students in professional programs such as archival studies, museum studies, library and information science, and cultural heritage management will find that this guide provides a step-by-step introduction to vocabularies, full of examples and demonstrations. The acronym list and Readings section are handy tools included in the Resources section.
- Administrators of cultural heritage collections will want to start with A View from the Top, a special message from David Green, Executive Director of the National Initiative for a Networked Cultural Heritage (NINCH). Green makes the case for adding value to collections through the use of vocabularies.
- Educators in professional programs such as archival studies, museum studies, library and information science, and cultural heritage management can use this publication as a self-guided course text. The Readings section includes references to Web guides and manuals, providing the basis for further assignments.

- Researchers and scholars (e.g., art historians, curators, architectural historians) can explore the use of vocabularies by looking at the examples in Chapter 6 and by using the Readings section to find suggestions for further information.

I have tried to provide as many examples as possible within the pages of this book, but you also will find abundant references to Web sites in the text. *Introduction to Vocabularies: Enhancing Access to Cultural Heritage Information* is available at http://www.gii.getty.edu/intro_vocabularies/. All of the URLs cited in this book can be accessed from one page in this site.

The task of trying to package a "workshop in a book" has been a gratifying and sometimes overwhelming experience. Fortunately, I was not alone. I am truly thankful for the vision, intelligence, and perseverance of the contributing editors: Howard Besser, Joy Davis, Patricia Harpring, Christine L. Sundt, Helen R. Tibbo, and especially Susanne Warren.

Elisa Lanzi

A View from the Top

A Special Message for Administrators of Cultural Heritage Collections

David Green
Executive Director
National Initiative for a Networked Cultural Heritage (NINCH)

Cultural heritage is a precious living resource, something we all contribute to and are part of in one way or another. Today, digital networking has the immense potential of bringing wide, equitable access to the texts, objects, sounds, and sights that form our global cultural heritage. It has the added potential of being able to show the complex interrelationships among these objects, their histories, and their contexts. By networking the materials held by thousands of collectors and repositories, we can tell the stories of the objects of creation and their creators in a much richer and more rewarding way than ever before.

However, there is an enormous amount of work for us all to do to ensure that this potential is achieved. Not only are the traditional activities of conservation and preservation still essential, but so also is the newer work of describing, cataloging, and encoding, rigorously and generously.

Implementing newly developed metadata standards and vocabularies will provide critical support for these efforts. This publication is designed to help you make informed decisions in this area by demonstrating how standards-based practice can help advance the overall mission of your institution. Specifically, it demonstrates how vocabularies can improve access:

- Vocabularies can be used as "assistants" in database search engines, creating a semantic network (or roadmap) that shows links and paths between concepts. When querying a database, users can follow these paths composed of synonyms, broader/narrower terms, and related concepts to refine, expand, and enhance their searches and achieve more meaningful results. When used as a search assistant, a vocabulary is a powerful knowledge base—linking searchers to information from both structured and unstructured databases.

- Vocabularies are sources of "standard terminology" for use in the description, cataloging, or documentation of cultural heritage collections. Vocabularies often reflect consensus of opinion within a community by answering the question "How do we talk (or write) about this particular subject area?" In doing so, vocabularies become valuable tools for professional catalogers and documentation staff who need to establish consistent access points.

Vocabularies play a critical role in the larger movement to create and apply standards that will improve access to cultural heritage information. This work requires creative collaborations among nations and disciplines in ways that have not been attempted before. Fortunately, several initiatives and projects are emerging to pave the way, and I highly recommend that you take a minute to look at the examples cited in Chapter 6 of this publication.

Cultural heritage could be the heart of the new world that is being created in cyberspace; it could be our lifeline in a world of information overload. However, we must be vigilant on many fronts—the intellectual, the political, and the economic—lest our heritage be robbed of its immense potential.

1. What Is Cultural Heritage Information and Why Is It Important?

What Is Cultural Heritage?

"Culture is the flow of meanings that people create, blend, and exchange. It enables us to build cultural legacies and live with their memory. It permits us to recognize our bonds with kin, community, nation state, and the whole of humanity. It helps us to live a thoughtful existence."* Cultural heritage is both the tangible evidence and the legacy of those activities, and can serve as a document of cultural life. Simply put, "cultural heritage . . . denote[s] the means through which cultural knowledge is transmitted."†

Exactly what is this evidence and where is it found? Created by members of a culture, it is found in texts (e.g., books, papers, alphabets), objects (e.g., paintings, pottery, tools), images (e.g., photographs, prints), the built environment (e.g., gardens, buildings, cities), and performances (e.g., dance, theater, films).

One way in which cultures recognize the importance of their cultural "evidence" is by entrusting it to institutions or organizations whose mission is to collect, preserve, and educate about the culture. Museums, libraries, archives, preservation societies, and visual teaching collections are some examples of this type of organization. Many cultures transmit and preserve their heritage through oral histories, events, and traditional practices. Holocaust survivor narratives, African dance, and Hungarian Gypsy songs are some examples of this type of cultural heritage preservation.

The benefits of providing all people with electronic access to a nation's cultural heritage are now being promoted by cultural leaders,

* UNESCO, *Living Cultures*. http://www.unesco.org/culture/index.htm
† Michael Buckland, *So What is Cultural Heritage?* http://info.berkeley.edu/courses/is142/f97/what.html

policymakers, and educators. A recent report* on the humanities and arts on the Internet lists some of these benefits:

- enriching a sense of community through active participation in a networked environment.
- improving the quality of teaching, and the learning of critical thinking, visual literacy, and analytical skills.
- fostering intellectual and artistic collaborations that will result in new resources in the arts and humanities.
- preserving the full complexities and quality of cultural information for the use of future generations while making it accessible to more people today.

This publication will demonstrate how vocabularies play a crucial role in support of this agenda, most notably in the area of preservation and access.

Adding Value to Cultural Heritage: Interpretation, Analysis, and Access

Imagine seeing the photograph on the opposite page in a gallery for the first time. There is no description on the wall next to it, no one to answer any questions, and you know little about this genre. You can certainly "appreciate" the fact that the photographer has a superb sense of the dramatic, that it depicts a single arresting figure, and even that, in your eyes, it is an aesthetically pleasing work of art. But beyond that, the image is "silent"—it cannot tell the complete story without the benefit of words.

This illustrates one of the most compelling and complex aspects of cultural heritage. Textual clues are few and far between in a building, a photograph, or a piece of pottery. Even an archival document, such as a letter written by a Civil War soldier, may not be fully appreciated without other contextual information (the soldier was African-American, from Massachusetts, and died the next day at the Battle of Fort Wagner).

Cultural heritage material has an intrinsic value, but only when documented and interpreted can it "tell the story" of a culture. These intellectual links (e.g., people, places, time, themes) exist in cultural her-

* *Humanities and Arts on the Information Highways: A Profile, Final Report*, September 1994. A national initiative sponsored by the Getty Information Institute (formerly the Getty Art History Information Program), the American Council of Learned Societies, and the Coalition for Networked Information. Available on the Web at http://www.gii.getty.edu/haif/index.html

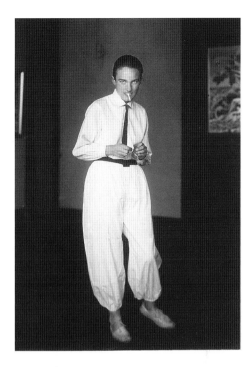

itage resources, and they are made explicit in the analysis and recording of information. The role of professionals in organizing and managing cultural heritage information is central to this challenge of providing interpretation, analysis, and access to cultural heritage.

Artist: August Sander
Nationality: German
Life Dates: 1876–1964
Title: *Wife of the Cologne painter Peter Abelen* (*Frau des Kölner Malers Peter Abelen*)
Date: 1926
Medium: Gelatin silver print
Dimensions: 23 × 16.3 cm (9^{1}/16 × 6^{7}/16 in.)
Notes: Sander spent the greater part of his career creating an ambitious series of photographs entitled *Menschen des 20. Jahrhunderts*. His goal was to describe as truthfully as possible every aspect of German society. This portrait of the wife of the painter Peter Abelen, surrounded by her husband's paintings, is full of ambiguity. If the title were unknown, one would wonder whether a male or female was represented and whether the face expressed hate or longing.
Location: J. Paul Getty Museum (84.XM.498.9)

Cultural Heritage Information: Ten Characteristics

1. Cultural heritage information opens up different worlds to new audiences

The traditions, objects, and artifacts of a culture are not always easily understood or appreciated by those outside the culture. Cultural heritage information helps to encourage exploration by identifying universal themes, explaining contexts, and revealing little-known facts.

2. Cultural heritage information tells a story

The information created to explain cultural heritage materials provides the interpretation and context necessary to "tell a story." Stories can help to make factual information more meaningful and accessible to hard-to-reach audiences.

3. Cultural heritage information is multidisciplinary

Many fields create or use cultural heritage information. For example, a group of Renaissance drawings showing London and its playhouses will be of great interest to art historians, architectural historians, archaeologists, dramatists, and sociologists, among others.

4. Cultural heritage information is international

Information is recorded, collected, and stored in many different languages. The growing presence of cultural heritage information on the Web is helping to create new international audiences for resources that were available previously only at a local level.

5. Cultural heritage information centers on an "act of creation"

A creative work, be it a novel, a mural, a dance performance, or a set of personal correspondence, and the context of its creation (who made it, where was it made, what does it mean, who collected it, etc.) form the core of cultural heritage information.

6. Cultural heritage information is a resource for education and entertainment

Education and entertainment are heavy "users" of cultural heritage information. The expanded use of multimedia in both fields has fueled a

demand for images and information from cultural heritage organizations. Intellectual property rights, historical accuracy, and multicultural points of view are central issues in the current dialogue about educational and entertainment use of cultural heritage information.

7. Cultural heritage information has a point of view

For example, a country may document its heritage from a nationalistic point of view. Writers and recorders reflect the language and bias of their respective fields of study. The values of one culture dictate how it talks about another culture's heritage. This subjectivity presents both a challenge for providing multiple points of view and an opportunity to preserve contextual information.

8. Cultural heritage information is recorded in a variety of media

Audio recordings, handwritten descriptions, films, logbooks, card catalogs, books, databases, 35 mm slides, and the Web are just some of the ways used to document and record cultural heritage information.

9. Cultural heritage information is usually not amenable to scientific analysis or quantification

Unlike scientific information, cultural heritage information shows itself best in words and pictures, not numbers.

10. Cultural heritage information is complex

Diversity of practice, traditions, methodologies, and the fact that cultural heritage information covers such a broad spectrum, from descriptions of objects or events (the who, where, and how) to interpretations (what does it mean?), make for a complex resource. This complexity presents a challenge for the creation of systems that provide seamless access to such diverse data.

2. Documentation: Analyzing and Recording Information

Different Approaches to Documentation

What is documentation and why is there such variation in practice among the cultural heritage communities? Documentation is the analyzing, organizing, and recording of information in order to provide access to cultural heritage resources. Methodology and practice in this area depend upon the nature, role, and perspectives of the holders of the information, as well as the nature of the information itself.

To accommodate the diverse forms that cultural heritage information takes, four major approaches to documentation have evolved over time: archival, library, museum, and visual resources. It is important to note that all four of these communities are currently re-examining their traditional practices as they attempt to deal with the digitization of and networked access to their materials. In order to appreciate this diversity, let's take a brief look at how these four approaches compare, contrast, and converge:

The Archival Approach
The archival approach entails the arrangement and description of records, personal papers, and manuscripts.

The archival approach:

- emphasizes the function and provenance of archival materials.
- applies to documents, images, artifacts, sound recordings, moving images, and electronic records.
- is based on the creation of a finding aid, which is a document that lists or describes a body of records within an archive, providing access to the user.
- describes collections, series, and groups of related materials, as opposed to cataloging individual items.
- is based on established standards, such as the MARC format, RAD, and APPM, as well as emerging ones like the EAD.*

* Please see the list on page 53 for acronyms not defined in the text.

- includes methodologies for the creation of catalog records, inventories, and registers.
- is based on the concept that the collection "in hand" is unique material.
- is not yet universally computerized.
- makes use of controlled vocabularies, such as LCSH and the AAT.
- is moving towards data-sharing initiatives that are motivated by the need for global access to unique and primary research material.

The following is an example of a cataloging record for a collection of archival materials.

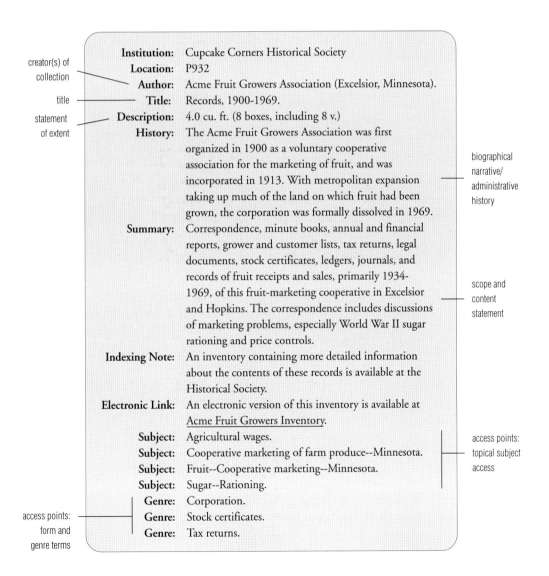

creator(s) of collection

title

statement of extent

Institution:	Cupcake Corners Historical Society
Location:	P932
Author:	Acme Fruit Growers Association (Excelsior, Minnesota).
Title:	Records, 1900-1969.
Description:	4.0 cu. ft. (8 boxes, including 8 v.)
History:	The Acme Fruit Growers Association was first organized in 1900 as a voluntary cooperative association for the marketing of fruit, and was incorporated in 1913. With metropolitan expansion taking up much of the land on which fruit had been grown, the corporation was formally dissolved in 1969.
Summary:	Correspondence, minute books, annual and financial reports, grower and customer lists, tax returns, legal documents, stock certificates, ledgers, journals, and records of fruit receipts and sales, primarily 1934-1969, of this fruit-marketing cooperative in Excelsior and Hopkins. The correspondence includes discussions of marketing problems, especially World War II sugar rationing and price controls.
Indexing Note:	An inventory containing more detailed information about the contents of these records is available at the Historical Society.
Electronic Link:	An electronic version of this inventory is available at Acme Fruit Growers Inventory.
Subject:	Agricultural wages.
Subject:	Cooperative marketing of farm produce--Minnesota.
Subject:	Fruit--Cooperative marketing--Minnesota.
Subject:	Sugar--Rationing.
Genre:	Corporation.
Genre:	Stock certificates.
Genre:	Tax returns.

biographical narrative/ administrative history

scope and content statement

access points: topical subject access

access points: form and genre terms

The Library Approach

The library approach entails the cataloging and classification of books and other published textual materials. This tradition is also known as bibliographic cataloging and classification.

The library approach:

- is based on the concept that the item "in hand" is one of many of the same thing. For this reason, data sharing is seen as economically advantageous (i.e., copy cataloging is cheaper than original cataloging).
- is guided by principles and practice originating from national leader institutions, e.g., the Library of Congress and the British Library.
- is taught in schools of library and information science, where the curriculum includes controlled vocabularies, authority practice, and subject analysis.
- places a high value on subject access.
- is facilitated by a long-standing tradition of data sharing, now dominated by national utilities and consortia, such as RLG and OCLC.
- is based on well-established standards, such as AACR2 and MARC format, and continues to develop new ones (e.g., the "core record concept" and Z39.50).

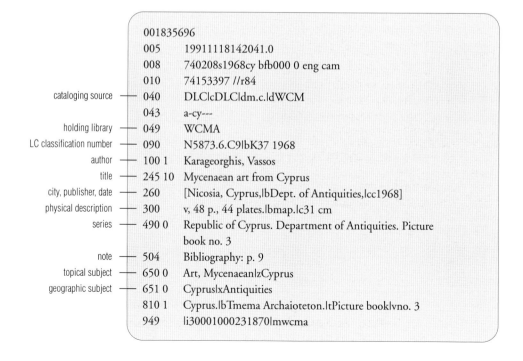

```
                        001835696
                        005      19911118142041.0
                        008      740208s1968cy bfb000 0 eng cam
                        010      74153397 //r84
cataloging source  ——   040      DLC|cDLC|dm.c.|dWCM
                        043      a-cy---
holding library    ——   049      WCMA
LC classification number —  090   N5873.6.C9|bK37 1968
author             ——   100 1    Karageorghis, Vassos
title              ——   245 10   Mycenaean art from Cyprus
city, publisher, date —  260     [Nicosia, Cyprus,|bDept. of Antiquities,|cc1968]
physical description —  300      v, 48 p., 44 plates.|bmap.|c31 cm
series             ——   490 0    Republic of Cyprus. Department of Antiquities. Picture
                                 book no. 3
note               ——   504      Bibliography: p. 9
topical subject    ——   650 0    Art, Mycenaean|zCyprus
geographic subject ——   651 0    Cyprus|xAntiquities
                        810 1    Cyprus.|bTmema Archaioteton.|tPicture book|vno. 3
                        949      |i30001000231870|mwcma
```

- includes methodologies for authority work and the use of standard vocabularies. LCSH is currently the most prevalent vocabulary in use.
- began to be computerized in the 1970s.
- was developed to provide "public access" to the materials cataloged.
- is based on item-level cataloging, i.e., a catalog record is created for an individual item, not a collection.
- is enhanced by analytics and abstracting/indexing services (such as BHA and the *Avery Index*).

The example on the previous page shows a cataloging record for the book *Mycenaean Art from Cyprus*, displayed in MARC format (courtesy of the Williams College Library).

FULL DISPLAY

TITLE:

America : bride of the sun : 500 years Latin America and the Low Countries : 1.2-31.5.92 : Royal Museum of Fine Arts, Antwerp.

PUBLISHED:

Brussels, Belgium : Flemish Community, Administration of 1991.

DESCRIPTION:

528 p. : ill. (some col.), maps (some col.) ; 30 cm.

NOTES:

Authors: Bernadette J. Bucher ... (et al.).
Essays translated into English chiefly from Dutch or Spanish.
Includes bibliographical references.

SUBJECTS:

Koninklijk Museum voor Schone Kunsten (Belgium)--Exhibitions.
Latin America in art--Exhibitions.
Benelux countries--Relations--Latin America.
Latin America--Relations--Benelux countries.
Art, Flemish--Exhibitions.
Art, Dutch--Exhibitions.
Art, Latin American--Exhibitions.

OTHER AUTHORS:

Bucher, Bernadette J.
Koninklijk Museum voor Schone Kunsten (Belgium)

ISBN:

9072191625

OCLC NUMBER:

26643699

A catalog record for an art exhibition catalog from an Online Public Access Catalog or OPAC (courtesy of the University of Texas at Austin, UT Library Online).

The Museum Approach

The museum approach entails the documentation of museum objects, e.g., works of art, artifacts, and specimens.

The museum approach:

- is complex, incorporating multiple aspects about an object, such as physical description, provenance, conservation, photographic documentation, and research data.
- is based on the concept that the item "in hand" is unique.
- has seen an increase in data-sharing initiatives in the last five years (e.g., the MESL and REACH projects). One exceptional example is the CHIN national inventories project, which began in 1972.
- uses classification schemes often based on departmental divisions or taxonomies such as *The Revised Nomenclature for Museum Cataloging.*
- incorporates images as well as textual data.
- has not universally adopted authority control as basic practice.
- has gained importance as a valuable source that can be re-purposed for public information systems.
- uses collection management systems geared to internal users (e.g., curators, registrars).
- uses diverse sources for terminology, such as the ULAN and the AAT (but for many museums, local lists prevail).

The following museum object record is from the collection management database of the Museum of Fine Arts, Boston.

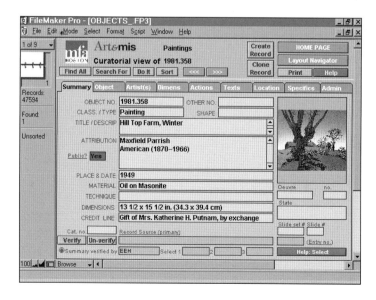

The Visual Resources Approach

The visual resources approach entails the cataloging, classification, and indexing of images.

The visual resources approach:

- provides access to images that enrich the educational experience. Many visual resources collections are in universities.
- describes both single items and sets of images.
- has complex levels of description, involving both the item "in hand" (e.g., a slide) and the content of the image.
- is working toward adoption of data standards, such as the "Core Categories for Visual Resources" and MARC.
- incorporates vocabularies, such as the AAT and the ULAN, but local lists and files are still most prevalent.
- values subject access, with systems such as ICONCLASS.
- is being implemented in data-sharing demonstration projects such as the VISION project with RLG.
- has close ties with the museum documentation tradition in the description of images of museum objects.
- uses highly developed, but nonstandard, classification systems.

The following SPIRO database cataloging record is for a slide in the collection of the Department of Architecture, University of California at Berkeley.

S * P * I * R * O Query Results

Call Number	tW74 B751 San3b.1
Image ID	94-110-001
Period	20th Century
Subperiod	Switzerland
Location	San Francisco, San Francisco County, California
Object Name	San Francisco Museum of Modern Art
Start Date	1992
End Date	1994
View Description	Exterior: entrance facade
Personal/Group	Botta, Mario--architect
Name--Role	Hellmuth, Obata & Kassabaum, Inc.--architectural firm
	Barnes, Richard--photographer
Subjects	entrances
	exterior views
	art museums
	Swiss
Source	San Francisco Museum of Modern Art
	151 Third Street, SF CA 94103-3159. (415)357-4000.
	(DONOR)
	Abbreviation: SF MoMA gift

Vocabularies Are the Bridge

The above documentation profiles show that vocabularies can offer a common ground for these different approaches. Vocabularies help to bring resources together in two ways:

1. The vocabularies that are being used in the four approaches are system-, application-, and media-independent. For example, a thesaurus such as the AAT provides terminology that can be applied in a variety of documentation situations ranging from highly structured records, such as those in MARC format, to free-text descriptions of museum objects using keywords.
2. Vocabularies are structured to provide links between terms that relate to each other in various ways (e.g., synonyms, spelling variants, and other related words). These links create an intellectual path that, if followed, can improve access to cultural heritage information. (See Chapter 4 for an explanation of how vocabularies work.)

Vocabularies can be used to bring together materials from archival, library, museum, and visual resources collections, as shown in the example on the next page.

Documentation and the Web

It's not surprising that many of the long-standing documentation principles and practices developed by the above-mentioned communities are influencing attempts to organize and document Web resources. For example, the numerous Web guides, such as Yahoo! and Lycos, use principles of classification to facilitate browsing and, ultimately, discovery of desired Web resources. Web search engines use "robots" to look for metatags (keywords) embedded in Web sites by creators, who "catalog" their own work. Some search engines, like Excite, are experimenting with ideas borrowed from thesaurus practice, such as linking concepts for users in order to aid searching.

Metadata standards (e.g., the Dublin Core) and intelligent search interfaces for digitized networked environments like the Web are being developed by professionals from the cultural heritage documentation communities (together with colleagues from the related field of artificial intelligence). Although it is beyond the scope of this publication to offer detailed coverage of metadata, Web search engines, and retrieval technologies, cultural heritage decision-makers and practitioners will want to be informed about these issues as they make decisions about the design of their own systems.

—**Slide of a painting** by Aaron Douglas, *The Negro in an African Setting*, in the collection of the New York Public Library, Schomburg Center. This slide resides in the University of South Florida College of Fine Arts slide collection.

—**Dissertation** by Jeff Richardson Donaldson, titled "Generation 306—Harlem, New York" (Northwestern University, 1974). This item was listed in the abstracting and indexing service *International Repertory of the Literature of Art* (RILA).

—**Digitized image of a photograph** of Augusta Savage alongside her sculpture, *Realization*, from the collections of the Archives of American Art. This image was located through the Archives of American Art Web guide.

AAT terms used:

1. Harlem Renaissance
 synonyms:
 Negro Renaissance
 New Negro Movement
 Renaissance, Harlem
 Renaissance, Negro
2. African American
 synonyms:
 Negro
 Black (style)
 Afro-American
3. artists
 synonyms:
 artist
 artist's
 artists'

—**Personal papers** of the black artist Palmer Hayden in the Archives of American Art collection. This item was located through the Smithsonian Institution Research Information System catalog.

—**Exhibition catalog**, *Harlem Renaissance: Art of Black America*, introduction by Mary Schmidt Campbell; essays by David Driskell, David Levering Lewis, and Deborah Willis Ryan (New York: The Studio Museum in Harlem/Harry N. Abrams, 1987). This item was found in the University of North Carolina at Chapel Hill Online Library Catalog.

—**Transcript of an interview** with "William A. Cooper, Negro Artist" from the "American Life Histories: Manuscripts from the Federal Writers' Project, 1936–1940" collection at the Library of Congress. This item was located through the American Memory Digital Library Web site.

—**Photograph** of the artist Romare Bearden in the collection of the National Portrait Gallery. Bearden was one of the curators of the seminal exhibition, *Harlem on my Mind*. This image was found in the National Portrait Gallery's "Catalog of American Portraits."

These items were linked using just three AAT descriptors and their synonyms (historical terms, spelling variants, and alternate forms of speech) as search terms. This example demonstrates how vocabularies can be used across communities to link cultural heritage information.

3. Standards: What Role Do They Play?

Why Standards?

Assume you are writing a paper to present at a conference in another city. Before leaving for the airport, you copy your paper to a $3^1/_2$-inch floppy disk, knowing that when you get there you'll want to add some last-minute thoughts. An hour before your talk, you borrow a friend's laptop computer and insert the disk. Wouldn't you be surprised (and upset!) if your disk didn't fit into the slot of your friend's computer? Fortunately, the computer industry developed and adopted a standard for a uniform size of disk.

This example illustrates how standards are used to control outcomes, so that you can be sure to get what you expect—every $3^1/_2$-inch disk fits into every computer all the time. Standards are useful in all fields and, in today's highly technical culture, are essential for the smooth operation of systems that govern our daily lives.

- Standards are mutually agreed upon statements that help to control an action or product. They may be created to establish consistency within an organization, a group of organizations, a country, or the global community.
- Standards represent professional consensus on best practice. The process that produces standards typically brings together knowledgeable practitioners to codify a reasonable body of practice based on a wide range of experiences.

Standards for Improving Documentation: Data Standards

The term "standards" can sometimes be intimidating because there is a perception that standards are inflexible. Actually, standards encompass a broad range of choices, from highly technical, exacting standards to recommended guidelines for practice. There is a special category of stan-

dards designed to improve the documentation and retrieval of information—data standards. You will find that many of the "standards" for cultural heritage information are actually guidelines, or guideposts that begin to define and identify the critical elements necessary to improve access. Fortunately, standards come in a variety of sizes and shapes specifically built to serve special purposes and communities.

There are four types of data standards, as described below. When used together, they are designed to improve access to your information.

1. *Data structure standards* define the categories into which information is to be divided. They establish what data elements will be included in a database record. For example, there might be a category for the artist's or author's name and a category for the date the work was created. Some data structure standards serve as guidelines, like the CDWA and the "Core Categories for Visual Resources." Others, like the MARC format and the EAD, function as both data structure and data communication standards.

 The outline of the CDWA is shown on page 18.

2. *Data communication standards* facilitate the interchange of information by specifying both a data structure and the way in which the individual data values are coded or labeled within that structure. The MARC Format and the Encoded Archival Description (EAD) are both communication standards that have these qualities. For example, the MARC format specifies that a field designated 650 be used for data on the subject matter of an item. The data entered there is coded according to a carefully defined protocol. The EAD Document Type Definition (DTD) is a standard for encoding archival finding aids using the Standard Generalized Markup Language (SGML). The standard is maintained in the Network Development and MARC Standards Office of the Library of Congress (LC) in partnership with the Society of American Archivists (SAA).

3. *Data content/syntax standards* are guidelines that govern the order, syntax, and form in which the data values are entered into the structure categories. For example, you need rules to tell you whether to input "Picasso, Pablo" or "Pablo Picasso" in the artist name field. Guidelines help decide whether to use "19th c." or "1801–1899" in the date field. AACR2 is a data content standard used by many organizations as a guide for data entry.

 The example on page 19 illustrates a standard that is used to govern data content.

Categories for the Description of Works of Art
The Getty Information Institute • College Art Association
INDEX DEFINITIONS Go to INTRODUCTION

Download Rich Text [RTF] File of the Outline
Download Document [DOC] File of the Outline

OBJECT/WORK CORE
-QUANTITY
-TYPE CORE
-COMPONENTS
 -QUANTITY
 -TYPE CORE
-REMARKS
-CITATIONS

CLASSIFICATION CORE
-TERM CORE
-REMARKS
-CITATIONS

ORIENTATION/ARRANGEMENT
-DESCRIPTION
-REMARKS
-CITATIONS

TITLES OR NAMES CORE
-TEXT CORE
-TYPE
-DATE
-REMARKS
-CITATIONS

STATE
-IDENTIFICATION
-REMARKS
-CITATIONS

EDITION
-NUMBER OR NAME
-IMPRESSION NUMBER
-SIZE
-REMARKS
-CITATIONS

MEASUREMENTS
-DIMENSIONS
 -EXTENT
 -TYPE
 -VALUE
 -UNIT
 -QUALIFIER
 -DATE
-SHAPE
-SIZE
-SCALE
-FORMAT
-REMARKS
-CITATIONS

MATERIALS AND TECHNIQUES
-DESCRIPTION
-EXTENT
-PROCESSES OR TECHNIQUES
 -NAME
 -IMPLEMENT
-MATERIALS
 -ROLE
 -NAME
 -COLOR
 -SOURCE
 -MARKS
 -DATE
-ACTIONS
-REMARKS
-CITATIONS

FACTURE
-DESCRIPTION
-REMARKS
-CITATIONS

PHYSICAL DESCRIPTION
-PHYSICAL APPEARANCE
 -INDEXING TERMS
-REMARKS
-CITATIONS

INSCRIPTIONS/MARKS
-TRANSCRIPTION OR DESCRIPTION TYPE
-AUTHOR
-LOCATION
-TYPEFACE/LETTERFORM
-DATE
-REMARKS
-CITATIONS

CONDITION/EXAMINATION HISTORY
-DESCRIPTION
-TYPE
-AGENT
-DATE
-PLACE
-REMARKS
-CITATIONS

**CONSERVATION/
TREATMENT HISTORY**
-DESCRIPTION
-TYPE
-AGENT
-DATE
-PLACE
-REMARKS
-CITATIONS

CREATION CORE
-CREATOR CORE
 -EXTENT
 -QUALIFIER
 -IDENTITY CORE
 -NAMES CORE
 -DATES/
 LOCATIONS CORE
 -BIRTH
 -ACTIVE
 -DEATH
 -NATIONALITY/CULTURE/RACE CORE
 -NATIONALITY/ CITIZENSHIP
 -CULTURE
 -RACE/ETHNICITY
 -GENDER
 -LIFE ROLES CORE
 -ROLE CORE
 -STATEMENT
-DATE CORE
-PLACE
-COMMISSION
 -COMMISSIONER
 -TYPE
 -DATE
 -PLACE
 -COST
-NUMBERS
-REMARKS
-CITATIONS

OWNERSHIP/ COLLECTING HISTORY
-DESCRIPTION
-TRANSFER MODE
-LEGAL STATUS
-COST OR VALUE
-OWNER
 -ROLE
 -PLACE
 -DATES
 -OWNER'S NUMBERS
 -CREDIT LINE
-REMARKS
-CITATIONS

COPYRIGHT/RESTRICTIONS
-HOLDER NAME
-PLACE
-DATE
-STATEMENT
-REMARKS
-CITATIONS

STYLES/PERIODS/ GROUPS/MOVEMENTS
-DESCRIPTION
-INDEXING TERMS
-REMARKS
-CITATIONS

SUBJECT MATTER CORE
-DESCRIPTION
 -INDEXING TERMS CORE
-IDENTIFICATION
 -INDEXING TERMS CORE
-INTERPRETATION
 -INDEXING TERMS CORE
-INTERPRETIVE HISTORY
-REMARKS
-CITATIONS

CONTEXT
-HISTORICAL/ CULTURAL
 -EVENT TYPE
 -EVENT NAME
 -DATE
 -PLACE
 -AGENT
 -IDENTITY
 -ROLE
 -COST OR VALUE
-ARCHITECTURAL
 -BUILDING/SITE
 -NAME
 -PART
 -TYPE
 -PLACE
 -PLACEMENT
 -DATE
-ARCHAEOLOGICAL
 -EXCAVATION PLACE
 -SITE
 -SITE PART
 -SITE PART DATE
 -EXCAVATOR
 -EXCAVATION DATE
-REMARKS
-CITATIONS

EXHIBITION/LOAN HISTORY
-TITLE OR NAME
-CURATOR
-ORGANIZER
-SPONSOR
-VENUE
 -NAME
 -PLACE
 -TYPE
 -DATES
-OBJECT NUMBER
-REMARKS
-CITATIONS

RELATED WORKS
-RELATIONSHIP TYPE
-IDENTIFICATION
 -CREATOR
 -QUALIFIER
 -IDENTITY
 -NAMES
 -DATES/LOCATIONS
 -BIRTH
 -ACTIVE
 -DEATH
 -NATIONALITY/ CULTURE/RACE
 -NATIONALITY/ CITIZENSHIP
 -CULTURE
 -RACE/ETHNICITY
 -GENDER
 -LIFE ROLES
 -ROLE
 -TITLES OR NAMES
 -CREATION DATE
 -REPOSITORY NAME
 -GEOGRAPHIC LOCATION
 -REPOSITORY NUMBERS
 -OBJECT/WORK TYPE
-REMARKS
-CITATIONS

RELATED VISUAL DOCUMENTATION
-RELATIONSHIP TYPE
-IMAGE TYPE
-IMAGE MEASUREMENTS
-COLOR
-VIEW
 -INDEXING TERMS
-IMAGE OWNERSHIP
 -OWNER'S NAME
 -OWNER'S NUMBERS
-IMAGE SOURCE
 -NAME
 -NUMBER
-COPYRIGHT/ RESTRICTIONS
-REMARKS
-CITATIONS

RELATED TEXTUAL REFERENCES
-IDENTIFICATION
-TYPE
-WORK CITED
-WORK ILLUSTRATED
-OBJECT/WORK NUMBER
-REMARKS

CRITICAL RESPONSES
-COMMENT
-DOCUMENT TYPE
-AUTHOR
-DATE
-CIRCUMSTANCE
-REMARKS
-CITATIONS

CATALOGING HISTORY
-CATALOGER NAME
-CATALOGER INSTITUTION
-DATE
-REMARKS

**CURRENT
LOCATION** CORE
-REPOSITORY NAME CORE
-GEOGRAPHIC LOCATION CORE
-REPOSITORY NUMBERS CORE
-REMARKS
-CITATIONS

AITF Categories - Core Categories Revised
4/13/98

22.3. CHOICE AMONG DIFFERENT FORMS OF THE SAME NAME

22.3A. Fullness

22.3A1 If the forms of a name vary in fullness, choose the form most commonly found. As required, make references from the other form(s).

J.Barbey d'Aurevilly
(*Most common form:* J. Barbey d'Aurevilly)
(*Occasional forms:* Jules Barbey d'Aurevilly; Jules-Amédée Barbey d'Aurevilly)
(*Rare form:* J.-A. Barbey d'Aurevilly)

Morris West
(*Most common form:* Morris West)
(*Occasional form:* Morris L. West)

Juan Valera
(*Most common form:* Juan Valera)
(*Occasional form:* Juan Valera y Alcala Galiano)

If no one form predominates, choose the latest form. In case of doubt about which is the latest form, choose the fuller or fullest form.

Sample page from the "Headings for Persons" section of *Anglo-American Cataloguing Rules* (AACR2), second edition, 1988 revision, p. 387.

4. *Data value standards* govern the terms or words that will be input into the categories established by the data structure. Controlled vocabularies and authority files regularize and standardize the terminology so that similar items can be retrieved in a search. For example, a personal name authority file will indicate which name among a number of variants (Paul Smith, Paul J. Smith, Paul Joseph Smith, etc.) should be used to refer to a certain individual. A structured subject vocabulary will link synonyms such as "tall buildings" and "skyscrapers" in a database so that searchers get better results.

The *Art & Architecture Thesaurus,* the *Union List of Artist Names,* and the *Getty Thesaurus of Geographic Names* are examples of data value standards. See Chapter 5 for illustrations.

How do data standards work together? The data structure is the container into which the data values (the terms) are placed according to the data content (the rules). Use of these tools combined with the powerful information exchange capabilities of data communication standards result in improved documentation and access to cultural heritage information.

What Are the Benefits of Standards?

Standards Improve the Quality and Consistency of Information
Because standards have been developed as a result of mutual agreement, they reflect well-reasoned and informed decisions, arrived at by consensus. Adopting standards at a local level takes advantage of this body of knowledge and experience, therefore improving the quality and consistency of information.

Standards Improve Compatibility of Information Structures
Using standard data structures and vocabularies will ensure that your data is compatible with other databases in the field. In the future, it may not be necessary for every database to use exactly the same data structure or vocabulary, because researchers are experimenting with creating "crosswalks" among different standards. For example, the field "artist name" in one data structure would be linked to a field called "artist" in another, thus creating a crosswalk between the two structures. The activity of creating a crosswalk is termed *mapping*. The desired outcome is called *interoperability*. It emphasizes access and practicality, yet preserves unique points of view as represented by different data standards.

Standards Protect the Long-term Value of Data
Standards for documentation had been in existence long before the advent of the computer and the Web. The fact that you may have been using a standard format or vocabulary in your index card files will ensure that your data, which is precious intellectual property, is preserved for future applications. For example, the use of standards can facilitate retrospective cataloging projects by providing a common base from which to move data from one system to another.

Standards Facilitate Information Retrieval and Exchange
Standards enable and foster the interchange of information. For example, providing remote access to library records using off-the-shelf software would not be possible without the adoption of the MARC format as the accepted data standard.

4. What, Why, and How of Vocabularies

Vocabularies as Knowledge Bases

A vocabulary is a body of knowledge represented by language. It answers the question "How do we talk (or write) about this particular subject area?" Glossaries, dictionaries, thesauri, and word lists are all examples of vocabularies. Most vocabularies focus on a special subject area (e.g., a glossary of geographical terms) or audience (e.g., a dictionary for the architecture and construction trades).

Controlled vocabularies are collections of words and phrases (called terminology) that are structured to show relationships between terms and concepts. One of the tasks of a controlled vocabulary is to bring consistency to language used in information retrieval contexts, be it a card catalog or a computerized database. For example, a vocabulary for furniture would show that there is a relationship among the three terms *bookcase, book case,* and *book-case.* In this example, the relationship is quite simple: They are spelling variations for the same concept, a piece of case furniture with shelves for books.

Why do we need vocabularies?
Because language is ever-changing, nuanced, and complex. The very characteristics that make language so wonderfully expressive can cause ambiguity and confusion in documentation, and ultimately hamper access to materials in databases. Here are a few examples of how language can cause confusion:

National and regional differences
A particular type of a rectangular, gable-roofed barn is called a Connecticut Barn in the United States. The same type of barn is called an English Barn in Great Britain.

Historical and contemporary names
The nation that is today called Iran was, before 1935, called Persia.

Indigenous vs. culturally inappropriate terms
Both KhoiKhoi and Hottentot are terms that have been used to refer to a group of people in Southern Africa. In early 20th-century Western texts, these people were called Hottentot. Today, KhoiKhoi is preferred and Hottentot is now considered culturally inappropriate.

Linguistic differences
The Italian artist Tiziano is called Titian in English and Titien in French.

Controlled vocabularies are designed to identify and make these connections among terms by managing synonyms and disambiguating homographs, resulting in improved results for the database searcher. In this way, the terms in the vocabulary serve as a knowledge base for the materials in the database. Vocabularies are most effective when used together with other standards, especially data structure and data content standards.

Vocabularies: Types and Formats

A wide range of controlled vocabularies has been developed to help describe and access cultural heritage information. Many of these vocabularies were created and are maintained by research institutes, national and international cultural organizations, and professional societies and associations. They can be used individually or together, depending on the type of material being described.

Following are examples of types of terms that can be found in controlled vocabularies available for describing cultural heritage:

- personal names
 (in the *Union List of Artist Names* you will find Georgia O'Keeffe)
- geographic place names
 (in the *Getty Thesaurus of Geographic Names* you will find Botswana)
- corporate names
 (in the *Library of Congress Name Authority File* you will find Metropolitan Museum of Art, New York, NY)
- object names
 (in the *Art & Architecture Thesaurus* you will find scroll paintings)
- iconographic subjects and themes
 (in ICONCLASS you will find the education of Cupid by Venus and Mercury)
- genre terms
 (in the *Thesaurus for Graphic Materials II: Genre and Physical Characteristic Terms* you will find political cartoons)

- multilingual terms
 (in the *Multilingual Egyptological Thesaurus* you will find the term pottery in English, German [keramik], and French [céramique])

Controlled vocabularies also come in a variety of formats to fit different practices, systems, and local needs, as listed below:

Subject heading lists are compilations of headings, usually displayed in alphabetical order. Headings are words, phrases, or combinations of words and modifiers that combine separate concepts into a "string."

The following example is excerpted from the *Library of Congress Subject Headings* (LCSH), 18th edition, 1995.

Portrait prints (May Subd. Geog.)
 UF Engraved portraits
 BT Prints
 --17th century (May Subd. Geog.)
 --18th century (May Subd. Geog.)
 --19th century (May Subd. Geog.)
Portrait prints, American (May Subd. Geog.)
 UF American portrait prints
Portrait prints, British (May Subd. Geog.)
 UF British portrait prints
Portrait prints, Chinese (May Subd. Geog.)
 UF Chinese portrait prints
Portrait prints, European (May Subd. Geog.)
 UF European portrait prints
Portrait prints, French (May Subd. Geog.)
 UF French portrait prints
Portrait prints, German (May Subd. Geog.)
 UF German portrait prints
Portrait sculpture (May Subd. Geog.)
 BT sculpture
 NT Portraits, Group
 --18th century
 --19th century
 --20th century
 --South Dakota
Portrait sculpture, African (Not Subd. Geog.)
 UF African portrait sculpture

A **thesaurus** is a compilation of terms representing single concepts. A thesaurus displays relationships among terms by creating what is called a "semantic network." Thesauri are usually displayed as a hierarchy. Most thesauri display three types of relationships among terms: hierarchical (whole/part or genus/species), equivalence (synonyms), and associative (related terms). Thesauri are referred to as structured vocabularies, but in recent years this term also has been used to describe any vocabulary with a structure, even if it is not based on the above-mentioned thesaural relationships.

The following example from the *Art & Architecture Thesaurus* illustrates a section of the "Visual Works" hierarchy, showing the genus/species relationship.

```
FACET              Objects
HIERARCHY          Visual Works
DESCRIPTORS        <visual works by medium or technique>
                       sculpture
                           <sculpture by subject type>
                               death masks
                               life masks
                               scarabs
                               statues
                                   colossi
                                   equestrian statues
                                   figurines…
                                   korai
                                   kouroi
```

Classifications organize a body of knowledge into conceptual categories. Classification schemes such as *The Revised Nomenclature for Museum Cataloging* and ICONCLASS are intended to be used as organizational schemes for collections. Sometimes, classifications such as these serve double duty when catalogers extract individual terms and use them as data values in a field, outside the context of the rest of the classification scheme. For example, a museum may use the individual term "costume" from *The Revised Nomenclature for Museum Cataloging* without adopting its ten-category classification scheme to organize the museum's collection.

The following is a section from *The Revised Nomenclature For Museum Cataloging : A Revised and Expanded Version of Robert G. Chenhall's System for Classifying Man-Made Objects.**

* Walnut Creek, CA: AltaMira Press, 1995, p. 9.

Category: 2: FURNISHINGS
 BEDDING
 BAG, SLEEPING
 BEDSPREAD
 BLANKET
 BOLSTER
 |
 |
 COMFORTER
 Counterpane . . . use BEDSPREAD
 COVER, BOLSTER
 |
 |
 MATTRESS
 |
 |
 PILLOW
 PILLOWCASE
 |
 SHEET

Building or Object Names Used in SPIRO

- B -

B'nei Adam

B.K. Pal House

Bab (Unidentified)

Bab al-Nasr

Bab Chorfa

Babelsberg Castle

Babelsberg Palace. Use Babelsberg Castle

Baburnama. Use Book of Babur

Baby Taj Mahal. Use I'timad-ud-Daula Tomb

Baby's Back

Bach de Roda (Bridge over Railway)

Bacino di San Marco

Backfill

Badshahi Mosque

Baensch House

Bagh-i-Fin

Bagh-i-Iram Villa

Bagh-i-Wafa. Use Garden of Fidelity

Baghdad Kiosk & Canopy of Sultans

Bailey House

Baixa

Bajada, La

Baker House Dormitory

Term lists are most often created by individual organizations and reflect the scope of the institution's collection. Many of these local lists include terms from other controlled vocabulary resources. Sometimes an organization will collaborate with a similar collection to create a joint term list. Term lists can be a rich resource for unique, regional, historical, or very specific terminology. In some organizations the term list also functions as the authority file.

The example in the margin is an excerpt (first part of the letter B) from the term list of the SPIRO online visual database at the University of California at Berkeley.

The Role of Authority Work

Authority work, in which terms and names are verified and validated, is a critical part of documentation practice. The concept originated in the library cataloging domain in the days of manual card catalogs and indexes when strict consistency was necessary for even minimal access. Today authority work has extended to other information management communities, and its processes and procedures have benefited greatly

from computerization. The development and application of standard controlled vocabularies is a significant outcome of authority work.

Authority work is defined by the following characteristics:

Authority files are compilations of authorized terms or headings used by a single organization or consortium in cataloging, indexing, or documentation. Authority files are strictly maintained as terms are applied, and often include associated information about the term or subject heading. This associated information can include synonyms (also known as "see references"), related or associated terms (also known as "see also references"), or original sources (e.g., the name of a particular dictionary where the term was found).

Authority control is a system of procedures that maintains consistent information in database records. This procedure includes the recording of terms and the validation of terms using the authority files. The purpose of authority control is to ensure that the database searcher can collocate like material and relate it to other materials in the database. Today authority control is important in the online environment for making searching easier for users and for improving precision in searching.

An authority file is a controlled vocabulary, but not all controlled vocabularies are authority files, because the main purpose of an authority file is to regulate usage in a particular database. In fact, you will find that some authority files use multiple structured vocabularies as a source for their files. For example, a historical society may use both the AAT and LCSH as a source for terms in the institution's subject authority files. Most authority files also include "local terms," originating from within the institution.

Authority files are an integral part of most automated information systems, but there are different levels of implementation depending on the systems. One of the most useful implementations involves making the authority file available as a resource for catalogers and as an interactive search assistant for users as they query the database.

Authority work procedures may be automated, but the intellectual processes needed to create high-quality authority files are still best carried out by humans. This work may include verification of the proposed term or name in authoritative sources, such as dictionaries, monographs, or (if relevant) historical sources; research of synonyms, such as variant spellings; establishing relationships to other terms/names in the authority file; and creation of an authority record to be added to the database. Authority work at the local level is often expensive and time-consuming; as data sharing becomes more prevalent, shared authority files are being explored.

The following authority file record for the author Umberto Eco is from the *Library of Congress Name Authority File* (NAF). Note the variant names (Eko, Umberto, etc.) and the sources of the information (Notes).

```
Heading:      Eco, Umberto
References:    Dedalus
              Eko, Umberto
              Eco, Humberto
              Eko, Oumperto
Notes:        His Il problema estetico in san Tommaso, 1956.
              Znepolski, I. B. Umberto Eko i ukhanieto na rozata, 1987.
              Såokratous, K. "Ho Aphorismenos," to "Onoma tou Rodou,"
              1989: cover (Oumperto Eko)
              O Pensamento do fim do sâeculo, c1993: t.p.
              (Humberto Eco) p. 113 (Umberto Eco; b. in Piemonte,
              01-05-1932)
              b. 1932; pseud. Dedalus
Control No.:  n 79021285
```

Vocabulary Building

Vocabularies are available for many different subject areas and audiences, but there are gaps in coverage, especially for specialized areas. If you embark on building your own vocabulary there are several good resources in the form of publications, training workshops, and academic courses. The following are recommendations for building new vocabulary:

- **Build on existing work.** Some established vocabularies like the AAT and LCSH offer opportunities to enhance specific areas. For example, the Mystic Seaport Museum staff recently researched and added terminology for vessel types to the AAT.
- **Incorporate maintenance into your plan.** In order for a structured vocabulary to be effective it needs to accommodate changes in the language.
- **Adhere to national and international standards** produced by NISO, ISO, and other standards organizations.
- **Find partners and collaborate with other like-minded groups.** For example, the MDA supports terminology working groups (such as the Ethnographic Terminology Working Group), which pool resources to create vocabularies.
- **Get training.** Schools of library and information science, cultural heritage management programs, and professional workshops are all sources for training in thesaurus construction and authority work.
- **Follow established methodologies.** For example, the Getty Information Institute has published *Guidelines for Forming Language Equivalents* to enable multilingual vocabulary building.

5. The Getty Vocabularies: An Introduction

The Getty Information Institute has developed three vocabularies, the *Art & Architecture Thesaurus* (AAT), the *Union List of Artist Names* (ULAN), and the *Getty Thesaurus of Geographic Names* (TGN) as part of its mission to provide tools to improve access to cultural heritage information. Together, the AAT, the ULAN, and the TGN encompass terminology covering object names and descriptive terms, artists' names and dates, and geography. These tools complement other Getty standards-based approaches to cultural heritage information management, such as the *Categories for the Description of Works of Art* (CDWA) and the Object ID Checklist.

The Getty vocabularies are excellent examples of "structured" vocabularies that can be used to improve access in two ways:

1. The Getty vocabularies are sources of "standard terminology" for use in the description, cataloging, and documentation of cultural heritage collections. In this context they are "data value standards." Vocabularies become valuable tools for professional catalogers and documentation staff who need to establish consistent access points.
2. The Getty vocabularies can be used as "assistants" in database search engines, creating a semantic network (or roadmap) that shows links and paths between terms and concepts. When querying a database, users can follow these paths composed of synonyms, broader/narrower terms, and related concepts to refine, expand, and enhance their searches and achieve more meaningful results. When used as search assistants, the vocabularies are powerful knowledge bases—linking searchers to information from a variety of databases.

As a practical application of this concept, the *a.k.a.* demonstration project shows how two of the Getty vocabularies (the AAT and the

ULAN) can be used to search across the large heterogeneous databases available on the World Wide Web.

The Getty vocabularies are dynamic works-in-progress allowing new terms to be added and older forms updated through an active Candidate Term Program. This program encourages contributions of terminology from professional catalogers and documentation staff within the cultural heritage communities. This consensual approach to vocabulary building helps ensure that vocabularies are adopted as data standards in those communities.

The following illustration shows terms (underlined) contributed through the AAT Candidate Term Program. This display shows how the Mystic Seaport Museum has flagged and inserted the candidate terms within a section of the AAT.

Art & Architecture Thesaurus
Including Mystic Seaport Museum Candidate Terms

<hunting and commercial fishing vessels>
 fishing vessels
 <fishing vessels by form>
 <u>**fishing schooners**</u>
 <u>**Gloucester fishing schooners**</u>
 <fishing vessels by function>
 <dredging vessels>
 <u>**brogans (watercraft)**</u>
 clam dredgers
 skipjacks
 crab scrapers
 <line fishing vessels>
 crabbing skiffs
 <handlining vessels>
 dory hand-liners
 longliners
 <net fishing vessels>
 driveboats
 <u>**menhaden steamers**</u>
 seiners
 trawlers
 draggers
 <u>**sponge boats**</u>
 <trapping vessels>
 lobsterboats
 <u>**Kingston lobsterboats**</u>
 gunning boats
 bushwack boats
 rail skiffs
 sneak boxes
 whaling vessels
 factory ships
 whale catchers
 whaleboats
 whaleships

The Art & Architecture Thesaurus

What is the AAT?

The AAT is a knowledge base representing terminology that answers the question "How do we talk or write about cultural heritage?" The AAT includes both the terminology needed to identify cultural heritage works (e.g., lithographs) and the vocabulary necessary to describe their attributes and characteristics (e.g., gilded, Medieval).

The AAT is:

- a data value standard that provides terminology for use in cataloging, indexing, and documentation practice. It is most effective when used in combination with data structure standards (e.g., CDWA) and data content standards (e.g., AACR2).
- a thesaurus built according to standards. The AAT follows the rules and conventions prescribed by standards organizations such as ISO, NISO, and other codes of practice for thesaurus construction.
- designed for use in both indexing and retrieval. It is intended to bridge the language of the indexer and that of the searcher. If the thesaurus is available at the time of the search query, the searcher can consult the AAT to see what likely terms are available for the query.
- a facilitator for information sharing among different types of collections. For example, the AAT can be used to describe subject matter for books in a library, works of art in a museum, records in an archive, or images on the Web.
- application-independent. The AAT can be applied in the electronic environment in a variety of applications (e.g., databases and search engines) as well as in manual indexing systems, such as a card file.
- an evolving and growing tool. The Candidate Term Program allows for ongoing community input and expansion of coverage in specialized subject areas.

What kind of terminology is in the AAT?

The AAT is more than just art and architecture, as the title might suggest. The AAT provides terminology for the description, documentation, and retrieval of cultural heritage information.

Although the geographic coverage of the AAT is global, its current focus is on the cultural heritage of Western Europe and North America. The Getty Information Institute Vocabulary Program has recently expanded both the chronological scope and the geographic coverage of the

AAT by incorporating additional data from a variety of external contributors. For example, a working group from the National Museum of African Art has added terminology for African styles and periods and object names.

The AAT includes terminology related to:

> works of art (e.g., painting, sculpture, mixed media)
> architecture (e.g., the built and natural environment)
> cultural traditions (e.g., events)
> material culture (e.g., furniture, costume, equipment)
> forms and genre (e.g., document types, records)

Imagine, for example, that you are describing this Mackintosh chair. The AAT provides nearly all of the vocabulary needed (AAT terms are in italics):

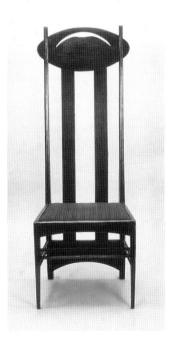

What is it?	high-backed *chair*
What is it made of?	*oak, horsehair*
How was it made?	*upholstered, stained, pierced*
Who made it?	Charles Rennie Mackintosh, *architect*
When was it made?	1898–99

What style is it?	*Arts and Crafts*
What is it part of?	*tea room*
What condition is it in?	reupholstered
How was it used?	*dining*
What is it about?	*anthropomorphic*
Where did it come from?	Miss Cranston's Argyle Street Tea Rooms
Where is it?	Glasgow School of Art, Glasgow

Note that the AAT does not include certain types of terminology. The areas listed below are covered by other thesauri and vocabularies:

Personal Names	Charles Rennie Mackintosh (ULAN)
Corporate Names	Glasgow School of Art (Library of Congress authority files)
Geographic Place Names	Glasgow (TGN)
Building Names	Miss Cranston's Argyle Street Tearoom (local authority)
Historic Events	Exhibition of Decorative Art, London, 1923 (Library of Congress authority files)
Iconographic themes	e.g., Venus and Cupid (ICONCLASS)

How does the AAT work?

AAT Structure—Facets, Hierarchies, and Terms

A framework of seven categories, called facets, serves as the foundation for the AAT structure. The idea for a faceted structure is based on the classification of knowledge into faceted categories, developed by S.R. Ranganathan in the 1930s. The seven facets are the top levels of the AAT's hierarchical structure.

The order of the AAT facets reflects the particular point of view needed for a knowledge base for art and architecture. The order of the facets progresses from abstract concepts (Associated Concepts Facet) to concrete, physical objects (Objects Facet).

Each facet is subdivided into hierarchies. Currently there are thirty-three hierarchies. The terms are displayed within the hierarchies by concept. The term you see in the hierarchical display is called a descriptor, which was chosen to represent the concept in the hierarchy. Following is a list of the seven AAT facets and thirty-three hierarchies.

FACETS	HIERARCHY NAME	CODE	SAMPLE TERMS
Associated Concepts	Associated Concepts	BM	symmetry, folk art, patronage
Physical Attributes	Attributes and Properties	DC	acid-free, jeweled, revolving
	Conditions and Effects	DE	cracks, insect damage, fingerprints
	Design Elements	DG	chevrons, arabesques, dots
	Color	DL	olive brown, monochrome, vivid red
Styles and Periods	Styles and Periods	FL	Mombasa, Romanesque, Fluxus
Agents	People	HG	bookbinders, performance artists, gardeners
	Organizations	HN	guilds, park commissions, academies
Activities	Disciplines	KD	aesthetics, ethnoarchaeology, urban design
	Functions	KG	importing, publishing, exhibiting
	Events	KM	coronations, hurricanes, pilgrimages
	Physical Activities	KQ	archery, boating, chess
	Processes and Techniques	KT	varnishing, mural painting, wattle and daub
Materials	Materials	MT	flax, wrought iron, tempera
Objects	Object Groupings and Systems	PC	tea services, irrigation systems
	Object Genres	PE	forgeries, automata, votive offerings
	Components	PJ	handles, anterooms, typefaces
	Settlements and Landscapes	RD	hamlets, edge cities, forests
	Built Complexes and Districts	RG	haciendas, campuses, historic districts
	Single Built Works	RK	cathedrals, potteries, hogans

Open Spaces and Site Elements	RM	topiary, bicycle paths, piazzas
Furnishings	TC	Adirondack chairs, torchères, Aubusson carpets
Costume	TE	kimonos, lorgnettes, waistcoats
Tools and Equipment	TH	looms, whetstones, palette knives
Weapons and Ammunition	TK	harpoon guns, scimitars, land mines
Measuring Devices	TN	sundials, transits, astrolabes
Containers	TQ	baskets, canopic jars, inkwells
Sound Devices	TT	violas, talking drums, sirens
Recreational Artifacts	TV	playing cards, horseshoes, kaleidoscopes
Transportation Vehicles	TX	galleons, bigas, fire engines
Visual Works	VC	master drawings, ukio-e, ambrotypes
Exchange Media	VK	tokens, centavos, postage stamps
Information Forms	VW	navigation charts, diaries, screenplays

The Semantic Network of the AAT

In the construction of the thesaurus, all terms representing a single concept have been collected together and one has been established as the descriptor. In the hierarchies the descriptors are graphically displayed to show their genus/species relationships (broader term/narrower term). This is the first element of the semantic network.

The example on page 35 shows a segment of the Furnishings Hierarchy in the *Art & Architecture Thesaurus.*

Next, synonyms, including variant spellings for that concept, are designated as Use For (UF) terms, and are linked to the descriptor. In addition to the hierarchical and synonymous relationships among AAT terms, the semantic network is enriched by a third element, the associative relationship, represented by the related term (RT) link. The lower example on page 35 is the term information record for armchairs.

```
<single seating furniture>
        chairs
                <chairs by form>
                        Adirondack chairs
                        armchairs
                                bergères
                                elbow chairs...
                                great chairs...
                        ax chairs
                        backstools
                                farthingdale chairs
                        Barcelona chairs
                        barrel chairs
                        Barwa chairs
                        basket chairs
                        beanbag chairs
```

AAT Term Information

Descriptor: armchairs
Hierarchy: Furnishings [TC]
Scope note - Term applied to a wide variety of chairs with arms, to distinguish them from side chairs that have no arms.
Alternate Forms of Speech {ALT}:
 armchair
Synonyms and spelling variants {UF}:
 arm chairs
 chairs, arm
 armed chairs
 chairs, armed
 arming chairs
 chairs, arming
 chaises à bras
You may also be interested in the following related concepts {RT}
 side chairs
 Morris chairs
 dining chairs
 hunting chairs
 lolling chairs
 reading chairs
 student chairs
 porters' chairs
 curricles (chairs)
 sleeping chairs
 Sleepy Hollow chairs

How is the AAT used?

The AAT can be used as a data value standard in the documentation (cataloging, indexing, and description) of cultural heritage information. Building on consensus within the community and research, the AAT establishes a preferred form of term (the descriptor) to be used as a consistent access point.

The AAT can be used as a search assistant in databases, by creating a semantic network or roadmap that shows links and paths among terms. When the AAT is applied to a database, users can follow these paths composed of synonyms, broader/narrower terms, and related concepts to refine, expand, and enhance their searches and achieve more meaningful results.

Even if the AAT is not applied in the documentation stage, when used as a search assistant it is a powerful knowledge base linking searchers to information.

The Union List of Artist Names

What is the ULAN?

The first edition of the ULAN (1995) was the product of a seven-year effort to merge artist and architect names and biographical data from nine Getty Trust projects and databases in a single reference. Using the ULAN, you can examine variant artist names from a wide range of contemporary and historical sources, including abstracting and indexing services, visual resource collections, object collections, and scholarly documentation projects. Names are supplemented by citations to more than 27,000 sources, including biographical dictionaries, scholarly articles, and historical inventory and auction information.

The following projects contributed data to the *Union List of Artist Names*:

AV	Avery Index to Architectural Periodicals
BA	Bibliography of the History of Art / Bibliographie d'Histoire de l'Art
CE	Census of Antique Art and Architecture Known to the Renaissance
FA	Foundation for Documents of Architecture
GC	Getty Research Institute, Photo Study Collection
JG	The J. Paul Getty Museum
PR	Provenance Index

VP	Getty Vocabulary Program
WC	Witt Checklist of Painters c. 1200–1976
WI	Witt Computer Index

The following ULAN record shows biographical information and variant names for the artist Artemisia Gentileschi.

Gentileschi, Artemisia [BA,GC,PR]

(Italian artist, 1597-p.1651)	[WC]
(Italian painter, 1593-aft.1651)	[GC]
(Italian painter, 1593-after 1651)	[BA]
(Italian painter, 1597-aft.1651)	[PR]
Artemesia Gentileschi	[PR]
Artemiggia	[PR]
Artemiscia Gentoleschi	[PR]
Artemisia	[PR]
Artemisia Gentilesca	[PR]
Artemisia Gentileschi	[PR]
Artemitia Gentilesca	[PR]
Artemizia Gentilesca	[PR]
Artimisia	[PR]
Gentileschi	[PR]
Gentileschi, Artemisia Lami (Schiattesi?)	[WC]
Lomi, Artemisia	[BA]

Bibliography:
*Bolaffi; *Encyc. world art; *RILA/BHA, 1986;
*Thieme-Becker

Note the contributor codes in the following ULAN record for Charles Rennie Mackintosh:

Mackintosh, Charles Rennie [AV,BA,GC,WC,WI]

(British architect, painter, 1868-1928)	[BA]
(British artist, 1868-1928)	[WC,WI]
(British painter and architect, 1868-1928)	[GC]
(Scottish architect, 1868-1928)	[AV]

Bibliography:
*Avery Libr. cat.; *Avery obit. idx.; *Dict. natl. biog.,
 1922; *Libr. of Congr. Name Auth. File; Pevsner, Dict. of
 arch.; *RILA/BHA; *Who was who [GBR], 1916

What kinds of terminology does the ULAN cover?

The ULAN includes more than 200,000 names representing nearly 100,000 artists (or "creators," including performance artists, decorative artists, etc.) and architects. Although the geographic coverage of the ULAN is global, its focus is on the post-medieval artists of Western Europe and North America. The Getty Information Institute Vocabulary Program plans to expand both the chronological scope and the geographic coverage of the ULAN by incorporating additional data from a variety of external contributors.

How does the ULAN work?

The ULAN does not advocate a single preferred form of an artist's name, but presents a range of choices that reflect art-historical usage. The "pluralistic" approach of this clustered format allows the ULAN to retain the integrity of the names established by the distinct, varied methods of its contributing projects, while at the same time fostering consistency by clearly showing patterns and frequency of usage of name forms and related data.

In the ULAN, all name forms (including pseudonyms, nicknames, and orthographic and linguistic variants) are clustered together in a single entry. Each entry also includes biographic data and bibliographic citations referring to the artist.

The following ULAN record for Hieronymus Bosch displays the cluster of name variants for this artist.

Bosch, Hieronymus (Hieronymus van Aken)	[BA,GC,PR]
(Netherlandish painter, ca.1450-1516)	[PR]
(Netherlands artist, op.1474-m.1516)	[WC]
(North Netherlandish painter, ca.1450-d.1516)	[GC]
(early Netherlandish painter, ca.1450-1516)	[BA]
Aeken, Hieronymus van	[BA]
Aken, Hieronymus van	[BA]
Ambrosius Bosch	[PR]
Bosch	[PR]
Bosch, Hieronymous	[PR]
Bosch, Hieronymous (Hieronymus van Aken)	[PR]
Bosch, Hieronymus	[GC,PR]
Bosch, Hieronymus (Hieronymus or Jerome van Aken)	[WC]
Bosch, Jerome	[PR]
Hieronymous Bosch	[PR]
Hieronymus Bosch	[PR]
Hieronymus van Aken	[PR]
J. Bos	[PR]
Jer. Bos	[PR]
Jeronimus Bosch	[PR]

How is the ULAN used?

The ULAN can be used as a source for authorities, or as a data value standard in the documentation (cataloging, indexing, and description) of cultural heritage information. Building on consensus among its contributing projects and on ranking according to scholarly usage, the ULAN establishes an "entry form" or heading that can be used as a collocating device or point of reference for all of the associated data relating to a particular artist or architect, including variant names, biographic information, and bibliographic citations.

The ULAN can be used as a searching tool to enhance retrieval in online environments. The ULAN has a "clustered" format: that is, all name forms (including pseudonyms, nicknames, and an unlimited number of orthographic and linguistic variants) associated with a particular artist or architect are linked in a single, merged record. This enables it to penetrate linguistic and historical barriers by providing more access points than ever before, precisely because of its inclusive nature. When used as a filter or retrieval engine to query a database or other online resource, the ULAN can help users to refine, expand, and enhance their searches and to retrieve more meaningful results.

Even if the ULAN has not been used in the documentation stage, when used as a search assistant or retrieval tool it is still a powerful knowledge base that can lead searchers to information in both structured and unstructured data resources.

The Getty Thesaurus of Geographic Names

What Is the TGN?

The TGN is a structured, hierarchical vocabulary containing names and other information about geographic places. The TGN database contains approximately 900,000 places arranged hierarchically to represent the political divisions of the contemporary world. The scope of the TGN is global; all continents and all nations are represented.

Information in the TGN was contributed by several Getty projects, including the *Bibliography of the History of Art* (BHA), the Foundation for Documents of Architecture (FDA), the Getty Research Institute's Photo Study Collection (GRIPSC), and the Getty Information Institute Vocabulary Program. In the future, the Vocabulary Program hopes to work with other institutions to update and supplement the database, with particular emphasis on the addition of historical names and historical facets.

The TGN data model is compatible with that suggested by the Thesaurus Artis Universalis (TAU) group of the Comité International

d'Histoire de l'Art (CIHA), published in the volume *A Methodological Approach to Producing a Historical/Geographical Databank.**

What kinds of terminology does the TGN cover?

The logical focus of a TGN record is the **place**. Each place record may have hierarchical placement, names, coordinates, place types, dates, and descriptive notes. Geographic places in the TGN can be either physical or political entities. They include physical features such as continents, rivers, and mountains, and political entities such as empires, nations, states, districts, townships, cities, and neighborhoods. The minimum record for each place represented in the TGN includes a name for the place and at least one "place type." The minimum name that is always included is the name in the language spoken in the place, the so-called vernacular name. If the place has a commonly used English name as well, this is generally included. The place type is a word or phrase that characterizes one or more significant aspects of the place, including its physical characteristics, role, function, size, or political anatomy (e.g., "island," "nation," "province," "inhabited place"). Depending on what contributors provide, a TGN record can also include further information such as alternate names, additional place types, and other information.

How does the TGN work?

The TGN contains approximately one million **names**. The TGN is a vocabulary, not an authority. It is not required to use any one form of name for a place. However, each place record in the TGN contains a so-called "preferred name" or entry-form name. It is necessary to flag one name to represent that place in the hierarchy and in alphabetical lists. Since the audience for the TGN is international, the preferred name is the name commonly used in the language of the place (the "vernacular name"). Even though one name is flagged as preferred for practical purposes, all names in the TGN are equal in retrieval; searching by any name, preferred or alternate, will retrieve the full record for the place.

Because one goal of the TGN is to provide wider access to art and bibliographic databases, one of the current and future priorities is to include as many alternate names as possible. Alternate names may include all variations in spelling (including differences in diacritical marks, punctuation, or capitalization), names in different languages, nicknames, and historical names. The commonly used English name for the place is generally flagged. Names may have associated "display dates," which are short notes describing when the name was used.

Most names in the TGN were derived from standard general reference sources, including the U.S. Geological Survey, atlases, loose maps,

* Serenita Papaldo and Oreste Signore. Rome: Editrice Multigrafia, 1989.

gazetteers, guide books, geographic dictionaries, encyclopedias, and Web sites, including the U.S. National Imagery and Mapping Agency. Other sources include books on the history of art and architecture, journal articles, newspaper articles, newsletters from ISO and the United Nations, letters and telephone calls to embassies, inscriptions on art objects, and catalog records of repositories of art objects.

The **place type** is a word or phrase that characterizes a significant aspect of the place, including its size, function, role, political anatomy, or physical characteristics. In the TGN, place types are indexing terms derived from a list of controlled vocabulary. One place type in each record is flagged "preferred." As with preferred names, a preferred place type is necessary because one place type must be selected to appear with the preferred name in an identification of the place.

In fuller records, additional place type terms have been included, and may be flagged as current or historical. Place types may have an associated display date, describing when or how the term applied to the place.

Approximately 90 percent of the place records in the TGN include **geographic coordinates**. The point indicated by the latitude and longitude represents a point in or near the center of the inhabited place, political entity, or physical feature. Although the TGN is currently not linked to associated maps, this may be possible with collaborators in the future.

For records that include supplemental information supplied by Getty editors, a **descriptive note** has been added to describe the place. This note may provide additional information about the place, or expand on information in other fields (including display dates for names and place types). Topics that may be covered in this note include the political history of the place, a physical description, and its importance relative to other places or to the history of art and architecture.

The **hierarchy** in the TGN refers to the method of structuring and displaying the inhabited places within their broader contexts. Since many places may have the same name, the name of a city alone does not identify it; for example, there are many towns and cities called "Columbus" in the United States. The city exists within the larger context of a county, which is part of a state, and the state in turn exists within the larger context of the nation.

For example, if museum users integrate the TGN's hierarchical structure into their database of objects, they can link their object record to a specific inhabited place (e.g., Columbus). However, they can still retrieve the record by searching for a broader context (e.g., Indiana), without having to make redundant entries for the inhabited place and all its broader contexts in each relevant object record.

Places are represented in the hierarchy by their "**preferred**" or **entry-form name** and a "preferred" place type in parentheses such as in

Firenze (inhabited place)

Lat: 43 47 N Long: 011 15 E

Note - Was Roman military center at head of navigation on Arno river & on Cassian Way; escaped capture by Goths 5th cen.; was thriving center by 12th cen.; torn by medieval Guelph/Ghibelline civil strife; was an early republic; ruled by Medici family from 1434.

Hierarchical Position:

 Europe..........................(continent)

 Italia..........................(nation)

 Toscana..........................(region)

 Firenze..........................(province)

Names:

 Firenze (C,V)

 Florence (C,O)

 Florencia (C,O)

 Florenz (C,O)

 Fiorenza (H,V).......................... medieval

 Florentia (H,V)........................ name of Roman colony on N bank of Arno

Place Types:

 inhabited place (C)................... site of ancient settlement, later founded as
 colony by Romans in 1st cen. BC, at foot of
 Etruscan hill town Fiesole

 city (C)

 regional capital (C)

 provincial capital (C)

 commune (administrative) (C)

 river settlement (C)........................ developed on both sides of the Arno river, is
 subject to periodic flooding; most bridges
 were destroyed in WW II

 tourist center (C)

 archiepiscopal see (C)bishops were established here early; today is
 famed for huge cathedral & baptistry & for
 numerous other churches

 industrial center (C)factories located in suburbs produce precision
 instruments & other items

 cultural center (C)noted as great center of art & literature since
 Middle Ages, especially flourished 14th-16th cen.

 transportation center (C)for road & river traffic since Roman times, now is
 also a major hub for rail traffic

 craftsman center (C)famed for traditional products, including
 textiles, glass, ceramics, metal wares,
 leatherwork, art reproductions & furniture

educational center (C)

financial center (C)Florentines were paramount bankers in Europe by 15th cen.

Florentines were leading bankers in Europe by 15th cen.

capital (H)of duchy of Tuscany

municipium (H)

Sources:

Fiorenza...Companion Guide: Florence (1979), 14 [VP]

Firenze...Columbia Lippincott Gazetteer (1961) [BHA]

Webster's Geographical Dictionary (1984) [GRIPSC]

Times Atlas of the World (1992), 66 [VP]

Companion Guide: Florence (1979), 62 ff. [FDA]

Florence...Webster's Geographical Dictionary (1984) [FDA]

Webster's Geographical Dictionary (1984) [GRIPSC]

Canby, Historic Places (1984), I, 296 [VP]

Encyclopædia Britannica (1988), IV, 838 [VP]

Webster's Geographical Dictionary (1988), 400 [VP-ENG]

FlorenciaRand McNally Atlas (1994), I-56 [VP]

Cassell's Spanish Dictionary (1978), 317 [VP]

FlorentiaPrinceton Encyclopedia (1979) [GRIPSC]

Princeton Encyclopedia (1979), 331 [VP]

Times Atlas of World History (1994), 343 [VP]

Florenz ...NIMA, GEOnet Names Server (1996) [VP]

the example for Firenze on page 42. Indention is used to indicate part/whole relationships—that is, broader and narrower contexts—for places in the hierarchy.

> South America (continent)
> Argentina (nation)
> Chaco (province)
> Barranqueras (inhabited place)
> Basail (inhabited place)
> Campo Largo (inhabited place)
> Charadai (inhabited place)

The main subdivisions in the hierarchy include the continents, nations, and main political subdivisions within nations (e.g., states, regions, provinces). Whenever possible, every nation has at least one level of subdivision, and some nations have two (e.g., the USA has the levels of state and county). Since the TGN hierarchy has too many levels to display on a computer screen simultaneously, the display usually shows only the

first level below the target place, and as many levels above it as possible. In this example, an ellipsis (. . .) indicates that there are additional places beneath a given level in the hierarchy.

> Africa (continent)
> Kenya (nation)
> Central (province) . . .
> Choichuff, Laga (river)
> Coast (province) . . .

Generally, the hierarchy in the TGN goes only to the level of the inhabited place. However, the level of neighborhood is included for some of the world's largest cities. TGN currently does not include streets or buildings within inhabited places.

> Europe (continent)
> Österreich (nation)
> Wien (state)
> Wien (inhabited place)
> Alte Donau (lake)
> Altmannsdorf (suburb)
> Aspern (suburb)
> Atzgersdorf (suburb)
> Augarten (park)
> Breitenlee (suburb)

Places in the TGN may be linked to multiple places as broader contexts. For example, a dependent state such as Bermuda is physically located in North and Central America; however, it is politically associated with the United Kingdom.

In the TGN, Bermuda's main position in the hierarchy represents its physical location.

> North and Central America (continent)
> Anguilla (dependent state) . . .
> Bahamas (nation) . . .
> Belize (nation) . . .
> Bermuda (dependent state) . . .

In Bermuda's alternate hierarchical view it displays under the United Kingdom. This alternate view is indicated with an upper-case "N" (indicating "nonpreferred") in the hierarchy.

> Europe (continent)
> United Kingdom (nation)

Anguilla [N] . . .
Bermuda [N] . . .
England (country) . . .

How is the TGN used?

The TGN is intended to be a source of geographic names for cataloging and retrieving records about works of art and artists, and for other disciplines. Geographic names are used to record the location of the art object, its place of origin, the loci of activity of the artist, and the sites of the artist's birth and death. The TGN provides users with vernacular and English names of places, as well as variant names in other languages, historical names, and other information. One of the most valuable uses of the TGN and the Getty Information Institute's other vocabularies will be as search assistants for querying large, disparate data sets.

In the future, the Getty Information Institute plans to update the TGN with the help of collaborators who will provide additional data or edit various sections. The plan includes: 1) adding more towns and villages in the current hierarchy, 2) adding more information about places already in the TGN, and 3) creating historical points of view.

6. Improving Access Using Vocabularies: Theory into Practice

The World Wide Web provides an excellent test-bed for demonstrating how vocabularies can enhance intellectual access in various applications. This section is a compendium of selected Web resources showing examples of vocabulary practice that you can use to:

- help you demonstrate the basic principles of vocabularies to colleagues.
- provide models for system developers.
- encourage collaborative projects in vocabulary building.
- teach vocabulary practice to students.
- create your own training exercises.
- help persuade decision-makers of the value of vocabularies.

Vocabularies as Search Assistants

The application of vocabularies as search assistants in cultural heritage databases is a relatively new practice, and most of the applications you will see on the World Wide Web are in the prototype stage. The theory has long been a research topic in artificial intelligence and information science labs, yet most of the applications have surfaced in scientific databases and commercial search engines. Fortunately, the arts and humanities sector will benefit from recent research initiatives, such as the **Digital Libraries Initiative** (DLI). The DLI is developing intelligent search interfaces for digital collections using vocabularies. The discussions in the "Semantic Research" and "Interspace Prototype" sections are especially relevant.

http://dli.grainger.uiuc.edu

a.k.a., developed by the Getty Information Institute, is an experimental search tool that uses the AAT and the ULAN to provide enhanced access to multiple databases of cultural information. This system allows you to simultaneously search thousands of records from several Getty databases such as the *Avery Index* and RILA.

http://www.gii.getty.edu/aka

ARThur is a demonstration project currently under development at the Getty Information Institute. ARThur uses the AMORE image system, developed by NEC, USA, Inc., to index and search images and text of nearly 600 Web sites organized into five databases. Images can be retrieved by image similarity, or by keywords in the Web pages. ARThur provides enhanced access through the use of the Getty vocabularies.

http://www.gii.getty.edu/arthur

BIRON—Bibliographic Information Retrieval Online. This database of the Economic and Social Research Council Data Archive at Essex University incorporates the HASSET (Humanities and Social Sciences Electronic Thesaurus) into the search interface. When you enter your search term or terms, BIRON tries to match your keywords or descriptive terms and geographical terms against several thousand terms arranged in associated groups in the HASSET thesaurus. When an exact match is found, you learn how many studies have been assigned the matching terms. At this stage you may elect to see the thesaural entry for the term, which may assist you in focusing your search. If no match is found, a list of similarly spelled terms is presented from which you may select a search term. HASSET is also an excellent social science thesaurus apart from its ability to search BIRON.

http://dawww.essex.ac.uk/about/biron.html

The UCLA Fowler Museum of Cultural History developed its prototype in collaboration with Questor Systems, the museum's collection management system vendor. Users can refine searches for museum objects and images by broadening or narrowing their topics. This is accomplished through a hierarchical lexicon that is made available at the time of the query. The search engine automatically includes synonyms and spelling variants in the search.

http://fowler.worldwidemuseum.org

Vocabularies in Image Databases

The Holsinger Studio Collection Image Database is a prototype created at the Alderman Library, the University of Virginia. The SGML tags were used to describe a set of photographs depicting 19th- and early 20th-century life in Virginia. The catalogers used both AAT and LCSH terms to provide topical access points.

http://www.lib.virginia.edu/speccol/holsinger/

The Image Directory, an online publication of Academic Press, is a resource of information on art images from a network of participating museums, libraries, societies, and other institutions. Several features are available to help image users find the precise information they need, including daily updates and additions of new material, low-resolution images for many entries, and direct links to the AAT and ULAN Web browsers. Access to the Image Directory is sold by subscription.

http://www.imagedir.com

The National Graphic Design Image Database was developed at the Herb Lubalin Study Center of Design and Typography, a division of the Cooper Union School of Art. The National Graphic Design Image Database is designed to electronically preserve and disseminate material related to the history and theory of graphic design. The database uses the AAT to describe design attributes for posters, advertisements, etc. The software enables students, designers, and artists to access and input images and analysis from Web sites worldwide and aims to build a virtual visual encyclopedia through an electronic community of educators. The public access version displays data for all the records, but access to images is currently restricted to select items. Educators interested in accessing the unrestricted version should contact Lawrence Mirsky, Director of the Herb Lubalin Study Center and the National Graphic Design Image Database, at mirsky@cooper.edu.

http://ngda.cooper.edu

The University of California at Berkeley Architecture Slide Library's SPIRO Online Visual Database uses a combination of AAT and local terms to describe this teaching collection of architectural slides. The site also includes a reference list of subject terms used in the database.

http://www.lib.berkeley.edu/ARCH

The University of California at Santa Cruz SlideCat Web site includes 200,000 textual records of slides and thousands of authority records. The categories can be browsed (including subject, artist, people, site, etc.), or keyword searches can be made. Sources for the authority files include the AAT and LCSH; however, they are not cited in the Web version. This site also uses the *Santa Cruz Classification System.*

http://slides-www.ucsc.edu/slidecat/slidecat.html

Vocabularies in Library Catalogs

IRIS, the Integrated Research Information System, is the online catalog for the Research Library of the Getty Research Institute. IRIS displays bibliographic records for more than 350,000 book and serial titles, as well as descriptions of approximately 3,000 archival and photograph collections. IRIS uses AAT terms in the form/genre descriptions for the collection.

http://opac.pub.getty.edu/screens/mainmenu.html

The National Art Library (London) staff collaborated with the AAT to create new subject terms in the area of book arts, including bookbinding and genre terminology. The AAT is the primary source of terminology for the NAL, and a project to convert older subject headings in the catalog to headings using AAT terms is under way. The NAL catalog can be searched via telnet from this site.

http://www.nal.vam.ac.uk/nalcomct.html

Vocabularies in Archival Description and Cataloging

The Duke University Papyrus Archive provides electronic access to texts about and images of Ancient Egyptian papyri. First read the online article "Cataloging the Duke Papyri" for an overview of the methodology used to create the database. This site is an excellent example of how data standards work together (e.g., MARC, APPM, AACR2, LCSH, and the AAT) to facilitate information retrieval in multiple environments (the Web, an OPAC, and an institutional catalog).

http://scriptorium.lib.duke.edu/papyrus

Vocabularies in Museum Documentation

The Mystic Seaport Museum is a good example of an institution-wide effort to integrate information from its library, archival, and museum collections. Mystic Seaport is employing several strategies to accomplish this:

in the area of vocabularies, the staff is actively researching and contributing terms to the AAT. These terms (together with others) will be used to provide access points into the collections databases.

http://www.mysticseaport.org/public/collections/collections.html

Examples showing how the *Categories for the Description of Works of Art* (CDWA) can be applied in documentation practice were created by the Getty Information Institute. Note how the AAT, ULAN, TGN, and ICONCLASS are used in multiple categories to describe a work of art.

http://www.gii.getty.edu/cdwa/examples/home3.htm

Vocabularies in Indexes

Conway Library Index–Architecture. This index to a microfiche collection of a photo archive for the history of architecture is a publication from Emmett Publishing. The Web version allows you to sample the index interface and retrieve up to three results per search. The editor, David L. Austin (Art and Architecture Librarian at the University of Illinois at Chicago), used a maximum of two AAT terms per photograph to help users find object types. The search form also includes a pop-up authority list of AAT terms used to index the photographs. The ULAN was consulted for spellings of names and dates of existence for people. A single version of the spelling of the name was chosen where multiples were found in the list.

http://www.emmettpub.co.uk/

The Program for Art on Film, Art on Screen database is an index to moving image productions on the visual arts. The database uses primarily AAT terminology, with some additions from LCSH. A subscription is required to search the entire database. The project is sponsored by the Pratt Institute School of Information and Library Science.

http://sils.pratt.edu/aofdb.html

RomeDAI. A guide for the photographs contained at the archives of the Deutsches archäologisches Institut in Rome. A significant part of this guide, created by David L. Austin, is a photo-by-photo database index of the contents of the microfiche publication of the DAI's photographic archive. The index includes the name of an item; a description of the view of an item; the name of a monument; the name of a site; the name of a region; the name of a country; the name of a repository; the repository's designation (inventory number); the name of a creator to whom the object

is attributed; term or terms related to the item's classification (from the AAT); term or terms related to the item's iconography (from ICON-CLASS); the location of the photo on the microfiche; and a credit for the original photo's source, including a photo or negative number when possible.

http://www.uic.edu/depts/lib/archartlib/RomeDAI/

Vocabulary Browsers

Vocabulary browsers are applications that give users access to the content of a vocabulary in an online environment. Other Web resources, such as online catalogs and databases, can take advantage of this by providing users with links to vocabulary browsers to assist in searching. Below are a few examples.

The Art & Architecture Thesaurus Browser, maintained by the Getty Information Institute, contains the most up-to-date AAT terminology. The ability to search individual words in scope notes is an added feature.

http://www.gii.getty.edu/aat_browser

CHIN Art & Architecture Thesaurus Browser, created by the Canadian Heritage Information Network, is available as part of the Research and Reference Information Resources package: tools for historic, terminology, and documentation research. A free 30-day trial subscription is available, or you can view a sample AAT record without a subscription.

http://www.chin.gc.ca/Resources/Research_Ref/Reference_Info/AATH/e_hp_aath.html

RLIN Art & Architecture Thesaurus Browser, offered by The Research Libraries Group as part of its RLIN database package of authority files. An RLIN or Zephyr subscription account is required to use the RLIN authority files.

http://www.rlg.org/aat.html

The Union List of Artist Names Browser, maintained by the Getty Information Institute, contains the most up-to-date ULAN information.

http://www.gii.getty.edu/ulan_browser

The Getty Thesaurus of Geographic Names Browser, maintained by the Getty Information Institute, contains the most up-to-date TGN information.

http://www.gii.getty.edu/tgn_browser

The ICONCLASS Browser is a tool developed by the ICONCLASS Research & Development Group (IRDG) at the Universities of Utrecht and Leiden. It is intended for those engaged in iconographic research or in the documentation of images, particularly for people working with ICONCLASS in computer projects. ICONCLASS is an iconographic classification system, i.e., a collection of ready-made definitions of objects, persons, events, situations, and abstract ideas that can be the subject of a work of art.

http://iconclass.let.uu.nl

Multilingual Vocabularies

The Religious Objects Collections database of more than 300 records of religious objects and images is sponsored by the Department of Canadian Heritage and the Ministère de la Culture de la France. The site currently displays descriptions in both French and English. A free thirty-day trial subscription is available, or you can view a sample record without a subscription.

http://www.chin.gc.ca/Resources/Research_Ref/Reference_Info/ACFR/e_hp_acfr.html

The Multilingual Egyptological Thesaurus, which has been compiled mainly for the computerized documentation and retrieval of museum objects, is a product of the collaboration between the Computer Working Group of the International Association of Egyptologists (IAE) and the Comité International pour l'Égyptologie (CIPEG) of the International Council of Museums (ICOM). This thesaurus browser provides terms in English, German, and French with future plans for Arabic, Italian, and Spanish. Note the numerical codes that link the same term in each language.

http://www.ccer.theo.uu.nl/thes/

Resources

Acronyms and Abbreviations

Complete citations for publications can be found in the Readings and Tools sections.

AACR2
Anglo-American Cataloguing Rules (second edition)

AAT
Art & Architecture Thesaurus

APPM
Archives, Personal Papers, and Manuscripts

Avery Index
Avery Index to Architectural Periodicals

BHA
Bibliography of the History of Art / Bibliographie d'Histoire de l'art

CDWA
Categories for the Description of Works of Art

CHIN
Canadian Heritage Information Network

DLI
Digital Libraries Initiative

EAD
Encoded Archival Description

ICONCLASS
Alphanumeric system for iconography

ISO
International Organization for Standardization

LCSH
Library of Congress Subject Headings

MARC
MAchine Readable Cataloging

MDA
Museum Documentation Association

MESL
Museum Educational Site Licensing Project

NAF
Library of Congress Name Authority File

NINCH
National Initiative for a Networked Cultural Heritage

NISO
National Information Standards Organization

NOMENCLATURE
Revised Nomenclature for Museum Cataloging

OBJECT ID
Object ID Checklist

OCLC
Online Computer Library Center

OPAC
Online Public Access Catalog

RAD
Rules for Archival Description

REACH
Records Export for Art and Cultural Heritage

RILA
International Repertory of the Literature of Art

RLG
The Research Libraries Group

RLIN
Research Libraries Information Network

SAF
Library of Congress Subject Authority File

SGML
Standard Generalized Markup Language

SHIC
Social History and Industrial Classification

TGM I and II
Thesaurus of Graphic Materials, I and II

TGN
Getty Thesaurus of Geographic Names

ULAN
Union List of Artist Names

VISION
Visual Resources Sharing Information Online Network

VR
Visual Resources

Z39.50
An interoperability standard of the American National Standards Institute

Readings

This section includes a special selection of readings to accompany Chapters 1–5. The readings are intended as an aid to further study in cultural heritage, documentation, standards, and vocabularies.

1. What Is Cultural Heritage Information and Why Is It Important?

Creative America: A Report to the President, Washington, DC: President's Committee on the Arts and Humanities, 1997.
see http://www.neh.fed.us/html/pcah.html

Excellence and Equity: Education and the Public Dimension of Museums. Washington, DC: American Association of Museums, 1992.
see http://www.aam-us.org/eenv.htm

Humanities and Arts on the Information Highways: A Profile, Final Report. September 1994. A national initiative sponsored by the Getty Information Institute, the American Council of Learned Societies, and the Coalition for Networked Information.
http://www.gii.getty.edu/haif/index.html

Jones-Garmil, Katherine, ed. *The Wired Museum: Emerging Technology and Changing Paradigms.* Washington, DC: American Association of Museums, 1997.

Paviscak, Pamela, Seamus Ross, and Charles Henry. *Information Technology in Humanities Scholarship: Achievements, Prospects, and Challenges—The United States Focus.* Occasional Paper No. 37. New York: American Council of Learned Societies, 1997.
http://www.acls.org/op37.htm

Research Agenda for Networked Cultural Heritage. Santa Monica, CA: Getty Art History Information Program, 1996.
http://www.gii.getty. edu/ranch/index.html

2. Documentation: Analyzing and Recording Information

Baker, Nicholson. "Annals of Scholarship: Discards." *The New Yorker* (April 4, 1994): 64–86.

Bell, Lesley Ann. "Gaining Access to Visual Information: Theory, Analysis, and Practice of Determining Subjects—A Review of the Literature with Descriptive Abstracts." *Art Documentation* 13, no. 2 (Summer 1994): 89.

Besser, Howard. "Integrating Collections Management Information into Online Exhibits: The Worldwide Web as a Facilitator for Linking Two Separate Processes." Paper presented at Museums and the Web: An International Conference, Los Angeles, CA, March 16–19, 1997.
http://www.archimuse.com/mw97/speak/besser.htm

Chan, Lois Mai. *Library of Congress Subject Headings: Principles of Structure and Policies for Application.* Washington, DC: Library of Congress, 1990.
see http://lcweb.loc.gov/ cds/lcsh.html#scmsh

Daniels, Maygene, and Timothy Walch, eds. *A Modern Archives Reader: Basic Readings on Archival Theory and Practice.* Washington, DC: National Archives Trust Fund Board, 1984.

Fidel, Raya, Trudi Bellardo Hahn, Edie Rasmussen, and Philip J. Smith. *Challenges in Indexing Electronic Text and Images.* Medford, NJ: American Society for Information Science, 1994.
see http://www.asis.org/Publications/Books/indexingchallenges.html

Fox, Michael J., and Peter Wilkerson. *Introduction to Archival Organization and Description,* ed. Susanne Warren. Los Angeles: Getty Information Institute, 1998.
http://www.gii.getty.edu/

Friedlander, Amy. "The Future is a Complex Place." *D-Lib Magazine* (May 1996).
http://www.dlib.org/dlib/may96/05editorial.html

Information: The Hidden Resource, Museums and the Internet. Proceedings of the Seventh International Conference of the MDA. Cambridge, UK: Museum Documentation Association, 1995.
see http://www.open.gov.uk/mdocassn/confproc.htm

Koch, Traugott, and Michael Day. *The Role of Classification Schemes in Internet Resource Description and Discovery.* Development of a European Service for Information on Research and Education (DESIRE) project deliverable, 1997.
http://www.ub2.lu.se/desire/ radar/reports/D3.2.3/ class_v10.html

Liu, Jian. *Understanding World Wide Web Search Tools* (May 1998).
http://www.indiana.edu/~librcsd/search/

Miller, Fredric M. *Arranging and Describing Archives and Manuscripts.* Chicago: Society of American Archivists, 1990.
see http://www.archivists.org

Miller, Paul, and Daniel Greenstein, eds. *Discovering Online Resources across the Humanities: A Practical Implementation of the Dublin Core.* London and Bath: Arts and Humanities Data Service, 1997.
http://www-ninch.cni.org/BOOKS/DORAH.html

Moir, Susanne, and Andrew Wells. "Descriptive Cataloguing and the Internet: Recent Research." *Cataloguing Australia* 22, nos.1–2 (March–June 1996): 8–16.

Nicholson, Scott. *Indexing and Abstracting on the World Wide Web: An Examination of Six Web Databases* (October 1997). http://www.askscott.com/iapaper.html

Pattie, Ling-yuh W., and Bonnie Jean Cox, eds. *Electronic Resources: Selection and Bibliographic Control.* Binghamton, NY: The Haworth Press, 1996.

Program for Cooperative Cataloging: An International Cooperative Program Coordinated Jointly by the Library of Congress and PCC Participants around the World (1996). http://lcweb.loc.gov/catdir/pcc/brochure.html

Subject Cataloging Manual: Subject Headings. 5th ed. Washington, DC: Library of Congress, 1996. http://lcweb.loc.gov/cds/lcsh.html#scmsh

Tibbo, Helen. "Indexing in the Humanities." *Journal of the American Society for Information Science* 45 (September 1994): 607–19.

Wallace, David A. "Managing the Present: Metadata as Archival Description." *Archivaria* 39 (Spring 1995): 11–21ff.

Web Developer's Virtual Library. *META Tagging for Search Engines* (January 1998). http://WWW.Stars.com/Search/Meta/Tag.html

Younger, Jennifer A. "Resources Description in the Digital Age." *Library Trends* 45, no. 3 (Winter 1997): 462–87.

3. Standards: What Role Do They Play?

Baca, Murtha, ed. *Introduction to Metadata: Pathways to Digital Information.* Los Angeles: Getty Information Institute, 1998.

Blackaby, Jim, and Beth Sandore. "Building Integrated Museum Information Systems: Practical Approaches to Data Organization and Access." Paper presented at Museums and the Web: An International Conference, Los Angeles, CA, March 16–19, 1997. http://images.grainger.uiuc.edu/papers/mweb215.htm

Blue Angel Technologies. *Z39.50 Explained* (January 1998). http://www.bluangel.com/NewsAndInfo/ FAQs/Z3950.htm

Dempsey, Lorcan. "ROADS to Desire, Some UK and Other European Metadata and Resource Discovery Projects." *D-Lib Magazine* (July/August 1996). http://www.dlib.org/dlib/july96/07dempsey.html

Developments in Museum and Cultural Heritage Information Standards. A joint project of the Getty Art History Information Program and the International Committee for Documentation (CIDOC) of the International Council of Museums (ICOM). Santa Monica, CA: Getty Art History Information Program, 1993. http://www.cidoc.icom.org/stand1.htm

Gill, Tony, Catherine Grout, and Louise Smith. *Visual Arts, Museums and Cultural Heritage Information Standards.* Visual Arts Data Service. http://vads.ahds.ac.uk/standards.html

Miller, Paul. "Metadata for the Masses." *Ariadne*, no. 5 (11 September 1996). Miller describes the Dublin Core and the means by which it can be implemented. http://www.ariadne.ac.uk/issue5/metadata-masses

Museum Informatics Project, University of California at Berkeley. *Standards in Museum Informatics* (January 1997). http://www.mip.berkeley.edu/ mip/standard.html

Sperberg-McQueen, C. M., and L. Burnard. "A Gentle Introduction to SGML." *Guidelines for Electronic Text Encoding and Interchange* (TEI P3) (1994). http://ota.ahds.ac. uk/teip3sg/

Walch, Victoria Irons, comp. *Standards For Archival Description: A Handbook.* Chicago: Society of American Archivists, 1994.

Weibel, Stuart, and Eric Miller. *Dublin Core Metadata Home Page* (November 1997). http://purl.oclc.org/ metadata/dublin_core

4. What, Why, and How of Vocabularies

Authority Control in the 21st Century: Proceedings of an Invitational Conference held at the OCLC Online Computer Library Center, Dublin, Ohio, March 31–April 1, 1996. http://www.oclc.org/oclc/man/authconf/procmain.htm

Bates, Marcia J. "How to Use Controlled Vocabularies More Effectively in Online Searching." *Online* 12, no. 6 (November 1988): 45–56.

Chamis, Alice Yanosko. *Vocabulary Control and Search Strategies in Online Searching.* Westport, CT: Greenwood Press, 1991.

Fidel, Raya. "Who Needs Controlled Vocabulary?" *Special Libraries* 83 (Winter 1992): 1–9.

Gilchrist, A.D. "Classification and Thesauri," in *Fifty Years of Information Progress: A Journal of Documentation Review*, 85-118. London: Aslib, 1994.

Johnson, Eric H., and Pauline A. Cochrane. "A Hypertextual Interface for a Searcher's Thesaurus." Paper presented at Digital Libraries '95: The Second Annual Conference on the Theory and Practice of Digital Libraries, Austin, TX, June 11–13, 1995. http://csdl.tamu.edu/DL95/papers/johncoch/johncoch.html

Jones, Susan, et al. "Interactive Thesaurus Navigation with Intelligence Rules." *Journal of the American Society for Information*

Science 46, no. 1 (January 1995): 52–59.
see http://www.asis.org/Publications/JASIS/jasis.html

Lancaster, F.W. *Vocabulary Control for Information Retrieval.* 2d ed.
Arlington, VA: Information Resources Press, 1986.

Lesk, Michael. *The Seven Ages of Information Retrieval*
(October 1995).
http://community.bellcore.com/ lesk/ages/ages.html

Library of Congress Experimental Search System (December 1997).
http://rs6.loc.gov/resdev/ess/experime.html

Milstead, Jessica. *Thesaurus Information.* American Society of
Indexers (1996).
http://www.asindexing.org/thesauri.htm

Roberts, D.A., ed. "Terminology for Museums." *Proceedings of an
International Conference held in Cambridge, England, 1988.*
Cambridge, UK: Museum Documentation Association, 1990.
see http://www.open.gov.uk/mdocassn/confproc.htm

Rowley, Jennifer E. *Organizing Knowledge.* 2d ed. Aldershot, UK:
Ashgate, 1992.

Rudner, Larry, and Liselle Drake. *Educational Resources
Information Center Search Wizard.* Version 2.0.
http://ericae.net/scripts/ewiz/amain2.asp

Shneiderman, Ben, Don Byrd, and W. Bruce Croft. "Clarifying
Search: A User-Interface Framework for Text Searches." *D-Lib
Magazine.*
http://www.dlib.org/dlib/january97/retrieval/01shneiderman.html

5. The Getty Vocabularies: An Introduction

Art & Architecture Thesaurus. 2d ed. 5 vols. New York: Oxford
University Press on behalf of the Getty Art History Information
Program, 1994.

Art & Architecture Thesaurus Bulletin. Williamstown, MA: Art &
Architecture Thesaurus [Getty Art History Information Program],
1979–1995.

Art & Architecture Thesaurus Sourcebook. A project of the AAT
Advisory Committee, ed. Toni Petersen, bibliography compiled by
Carol Jackman-Schuller. Raleigh, NC: Art Libraries Society of North
America, 1996.

Art & Architecture Thesaurus Web page.
http://www.gii.getty.edu/vocabulary/ aat.html

Bulletin of the Vocabulary Program. Los Angeles: Getty Information
Institute, 1997–.
http://www.gii.getty.edu/vocabulary/bulletin/ index.html

Directory of AAT Users. VRA Special Bulletin no. 8. Ann Arbor:
Visual Resources Association, 1995.

Getty Information Institute Vocabulary Program Web page.
http://www.gii.getty.edu/vocabulary/index.html

Getty Thesaurus of Geographic Names (TGN) Web page.
http://www.gii.getty.edu/vocabulary/tgn.html

Petersen, Toni, and Patricia J. Barnett, eds. *Guide to Indexing and
Cataloging with the Art & Architecture Thesaurus.* New York: Oxford
University Press on behalf of the Getty Art History Information
Program, 1994.

Ranganathan, S.R. *Colon Classification.* Madras: Madras Library
Association, 1933.

Union List of Artist Names (ULAN) Web page.
http://www.gii.getty.edu/vocabulary/ ulan.html

User Friendly: A Newsletter for AAT Users. Williamstown, MA: Art &
Architecture Thesaurus [Getty Art History Information Program],
1993–1997.

Web Guides, Indexes, Bibliographies

The American Council of Learned Societies. *American Arts and
Letters Network.* http://www.aaln.org/

Canadian Heritage Information Network. *Museology Bibliography*
(BMUSE), 1988–.
http://www.chin.gc.ca/Resources/Research_Ref/Reference_Info/
BMUS/e_hp_bmus.html

*Index Morganagus: A Full Text Index of Library-related Electronic
Serials.* Indexes journals such as *ASIS Bulletin, D-Lib Magazine,
Online, Searcher.*
http://sunsite.berkeley.edu/ ~emorgan/morganagus/

Information Science Abstracts. Alexandria, VA: IFI/ Plenum Data
Group. 1966–.

Intercat: A Catalog of Internet Resources.
http://orc.rsch.oclc.org:6990/

Library and Information Science Abstracts. London: Library
Association. 1969–.

Library Literature [CD-ROM]. Bronx, NY: H.W. Wilson
Company, 1987–.

McKiernan, Gerry. *Cyberstacks.*
http://www.public.iastate.edu/~CYBERSTACKS/homepage.html

Tools

This compendium includes tools, guides, manuals, organizations, projects, and training opportunities both on the Web and in print. It aims to be an exhaustive, yet useful, list of items relating to vocabularies. While the emphasis is on vocabularies, you also will find selected resources for documentation, cataloging, standards, and metadata. Many sites and Web guides offer comprehensive coverage in these areas; I have chosen a few sites that will lead you to the more specific resources.

1. Vocabularies

Guides
Selected Vocabularies
Classifications
Vocabulary Building
Projects and Initiatives

2. Documentation, Cataloging, and Description

3. Selected Standards and Metadata Tools

Data Content/Syntax
Structures and Formats

4. Helpful Organizations

5. Training Opportunities

1. Vocabularies

GUIDES

"Bibliography of Controlled Vocabulary Sources." *Visual Resources*, Special Issue, XI, nos. 3–4 (1996): 423–429.
This list was compiled by the Art Information Task Force in conjunction with the *Categories for the Description of Works of Art*.

Directory of Thesauri for Object Names/Inventaire des thesauri ou vocabulaires controlés des objets. ICOM-CIDOC, 1994.

Lutes, Barbara. *Web Thesaurus Compendium*. German National Research Center for Information Technology, Integrated Publication and Information Systems Institute (GMD-IPSI). A compilation of thesauri on the Web, including general thesauri and classifications and thesauri in specific domains or for special purposes.
http://www-cui.darmstadt.gmd.de/~lutes/thesauri.html

Middleton, Michael. *Controlled Vocabularies*. Queensland University of Technology. This page provides links to examples of thesauri and classification schemes that may be used as meta-information for controlling databases or Web page subject content.
http://www.fit.qut.edu.au/InfoSys/middle/ cont_voc.html

Museum Documentation Association. *wordHOARD*. A guide to terminology resources relevant to museums, including online thesauri, classification systems, and other authority files.
http://www.open.gov.uk/mdocassn/ wrdhrd1.htm

SELECTED VOCABULARIES

Getty Information Institute. *Art & Architecture Thesaurus* (AAT). With the AAT Web browser you can search all the terms in the AAT, browse through the hierarchies, view detailed information about terms, and search the scope notes.
http://www.gii.getty.edu/aat_browser

Getty Information Institute. *Getty Thesaurus of Geographic Names* (TGN). Contains approximately 900,000 records for places (one million names), arranged in hierarchies representing all nations of the modern world, and including vernacular and historical names, coordinates, place types, and other relevant information.
http://www.gii.getty.edu/tgn_browser

Getty Information Institute. *Union List of Artist Names* (ULAN). The ULAN Web browser allows you to search for artists by name or by biographical information, including artist's role (sculptor, photographer, architect); place of birth, activity, or death and life dates.
http://www.gii.getty.edu/ulan_browser

Library of Congress. *Library of Congress Catalogs, Name and Subject Authority Files*. To search these files on the Web, select the "Advanced Search" option in the "Word Search" section. A search form will appear allowing you to choose the specific file you wish to search. NAF, the international name authority file maintained by the Library of Congress, includes name authority records and series authority records created by LC and other libraries for use in cataloging. It contains about 4.1 million records. The *Subject Authority Files* (SAF, about 240,000 records) include subject headings established by the Library of Congress for use in cataloging.
http://lcweb.loc.gov/catalog

Library of Congress, Cataloging Policy and Support Office. *Library of Congress Subject Headings*. 20th ed., Washington, DC: Cataloging Distribution Service, Library of Congress, 1997. A standard subject heading list used by libraries and indexes. Provides an alphabetical list of subject headings, cross references, and subdivisions in verified status in the LC subject authority file.
http://lcweb.loc.gov/cds/lcsh.html#lcsh20

Library of Congress. Prints and Photographs Division. *Thesaurus for Graphic Materials I, Subject Terms* (TGM I). Includes 6,065 terms and cross references for the subject indexing of visual materials. Terms may be searched directly or browsed in alphabetical order. Companion volume to TGM II.
see http://lcweb.loc.gov/rr/print/tgm1

Library of Congress. Prints and Photographs Division. *Thesaurus for Graphic Materials II, Genre and Physical Characteristics Terms* (TGM II). TGM II is the 2nd edition of "Descriptive Terms for Graphic Materials: Genre and Physical Characteristic Headings" (1986). The thesaurus of 600 terms was developed by the LC Prints and Photographs Division, with input from other archival image repositories. The new name reflects its role as a companion to TGM I.
http://lcweb.loc.gov/rr/print/tgm2

U.S. Geographic Survey. *Geographic Names Information System.* The Geographic Names Information System (GNIS), developed by the U.S. Geographic Survey, in cooperation with the U.S. Board on Geographic Names, contains information about almost two million physical and cultural geographic features in the United States. The federally recognized name of each feature described in the database is identified, and references are made to a feature's location by state, county, and geographic coordinates.
http://mapping.usgs.gov/www/gnis/

National Imagery and Mapping Agency. *GEOnet Names Server.* Provides access to the National Imagery and Mapping Agency's (NIMA) database of foreign geographic feature names. Approximately 12,000 of the database's 3.3 million features are updated monthly with names information approved by the U.S. Board on Geographic Names.
http://164.214.2.59/gns/html/index.html

British Museum, Collections Data Management Working Party. *British Museum Materials Thesaurus,* 1997. This thesaurus was initially compiled from index terms used in curatorial documentation of the objects themselves. To create the thesaurus, the terms were vetted and incorporated into a hierarchical structure, and other thesaural features were added. It is not intended as a scientific classification system; rather it reflects the terminology, both current and historical, in use in curatorial departments in the British Museum. Terms may be proposed to the Working Party and, if suitable, added to the thesaurus.
http://www.open.gov.uk/mdocassn/bmmat/matintro.htm

ICOM International Committee for the Museums and Collections of Costume. *Vocabulary of Basic Terms for Cataloguing Costume.* A multilingual list in French, English, and German.
http://www.open.gov.uk/mdocassn/ costume/vbt00e.htm

Museum Documentation Association, English Heritage and Royal Commission on the Historical Monuments of England. *MDA Archaeological Objects Thesaurus,* 1997. This thesaurus is the result of work undertaken by the MDA Archaeological Objects Thesaurus Working Party, begun in 1995. The scope of the thesaurus is "any physical evidence, usually portable, resulting from past human activity and human interaction with the environment, or environmental remains, that can be recovered through archaeological fieldwork."
http://www.open.gov.uk/mdocassn/archobj/archcon.htm

Multilingual Egyptological Thesaurus, 1996. A vocabulary intended for documentation and retrieval of museum objects, the thesaurus is a collaboration between the Computer Working Group of the International Association of Egyptologists (IAE) and the Comité International pour l'Égyptologie (CIPEG) of the International Council of Museums (ICOM). In French, English, and German.
http://www.ccer.ggl.ruu.nl/thes/thesaur.html

Coombes, Judy. *Collection Thesaurus.* Sydney: Powerhouse Museum, 1995. The thesaurus used for documenting the collections of the Powerhouse Museum. Coverage includes social history, decorative arts, and science and technology.

CLASSIFICATIONS

Blackaby, James R. *The Revised Nomenclature For Museum Cataloging: A Revised and Expanded Version of Robert G. Chenhall's System for Classifying Man-Made Objects.* Walnut Creek, CA: AltaMira Press, 1995. *Nomenclature* is a hierarchical system for the classifying and naming of artifacts. The classification reflects the functionality of objects, as opposed to their form or origin.
see http://www.aaslh.org/publicat.htm

ICONCLASS Research and Development Group (IRDG) at the Universities of Utrecht and Leiden. ICONCLASS. Intended for those engaged in iconographic research or in the documentation of images, ICONCLASS is an iconographic classification system, i.e., a collection of 24,000 definitions of objects, persons, events, situations, and abstract ideas that can be the subject of a work of art. Each concept in ICONCLASS is represented by an alphanumeric notation with numerous cross references between thematically or visually related concepts.
http://iconclass.let.uu.nl

Library of Congress. Cataloging Policy and Support Office. *Library of Congress Classification.* A standard used by libraries to classify and physically arrange their collections by subject.
http://lcweb.loc.gov/catdir/cpso/lcco/lcco.html

OCLC Forest Press. *Dewey Decimal Classification* (July 1998). The Dewey Decimal Classification system is a general knowledge organization tool. It is the most widely used library classification in the world and has been translated into over thirty languages.
http://www.oclc.org/oclc/fp/index.htm

SHIC Working Party. *Social History and Industrial Classification* (SHIC), 1997. SHIC is a system for museum cataloging that classifies objects, photographs, archival material, tape recordings, and information files by area of human activity.
see http://www.holm.demon.co.uk/shic/

VOCABULARY BUILDING

International Organization for Standardization. *ISO 2788-1986 Guidelines for the Establishment and Development of Monolingual Thesauri*. Geneva: ISO, 1986.
see http://www.iso.ch/cate/d7776.html#0

National Information Standards Organization. *ANSI/NISO Z39. 19–1993 Guidelines for the Construction, Format, and Management of Monolingual Thesauri*. Bethesda, MD: NISO Press, 1994.
see http://www.niso.org/ pcindex1.htm#z3919

International Organization for Standardization. *ISO 5964-1985. Guidelines for the Establishment and Development of Multilingual Thesauri*. Geneva: ISO, 1985.
see http://www.iso.ch/cate/d12159.html#0

International Terminology Working Group. *Guidelines for Forming Language Equivalents: A Model based on the Art & Architecture Thesaurus* (September 1996).
see http://www.gii.getty.edu/guidelines/index.html

European Commission. *Eurodicautom,* 1997. This ten-language multilingual dictionary covers the terminology of all the activities of the European Union. Although not specifically addressed to cultural heritage, this application shows how multilingual vocabulary construction issues, such as partial equivalencies, can be treated.
http://www2.echo.lu/echo/databases/eurodicautom/en/eu92home.html

Aitchison, Jean, David Bawden, and Alan Gilchrist. *Thesaurus Construction and Use: A Practical Manual*. 3rd ed. London: Aslib, 1997.
see http://www.aslib.co.uk/pubs/15/01.html

Will, Leonard. *Publications on Thesaurus Construction and Use*.
http://www.willpower.demon.co.uk/thesbibl.htm

_____. *Thesaurus Principles and Practice*.
http://www.willpower.demon.co.uk/thesprin.htm

PROJECTS AND INITIATIVES

Department of Computer Science, University of Manchester. STARCH—*Structured Terminology for Archives*. This research project is constructing a pilot annotation and cataloging workbench for art archivists, driven by a structured terminological model of subject content and managed by description logic.
http://www.cs.man.ac.uk/mig/people/seanb/starch/

Dutch Ethnographic Thesaurus. Eight Dutch ethnographic museums have set up a project to develop a common thesaurus. The thesaurus will be in Dutch and will be developed inductively on the basis of the existing collections of the participating museums. As far as possible, the thesaurus will follow the structure and hierarchies of the AAT or internationally accepted agreements on terminology.
see http://www.open.gov.uk/mdocassn/internat.htm#dutch

European Research Consortium for Informatics and Mathematics. *Aquarelle: The Information Network on Cultural Heritage*. An international consortium of public and private cultural organizations supported by the Telematics Applications Programme of the European Commission for the purpose of sharing cultural information. A key component of this project is the development and deployment of multilingual terminology resources to support querying to databases offering documentation in different languages. A study has been carried out to assess current practices and expectations regarding the production of these resources.
http://aqua.inria.fr/

Getty Information Institute. *a.k.a.* (1996). A demonstration project using the AAT and the ULAN as "filters" or retrieval assistants for querying large, disparate data sets and Web sites.
http://www.gii.getty.edu/aka/

Library of Congress. *American Memory: Historical Collections for the National Digital Library*. A pilot project for the National Digital Library, American Memory provides access to digitized historical collections (photographs, prints, documents, motion picture, maps, and sound recordings). The Background Papers discuss the various access components in the project, including SGML, EAD, MARC format, Library of Congress vocabularies, and the INQUERY retrieval engine, among others.
http://lcweb2.loc.gov/ammem/

Term-IT. Coordinated by the MDA (June 1998). A European project providing multilingual support for multimedia services.
http://www.mda.org.uk/term-it

2. Documentation, Cataloging, and Description

Besser, Howard. *Image and Multimedia Database Resources* (November 1997). Links to resources and tools for image documentation.
http://sunsite.Berkeley.EDU/Imaging/ Databases/

Canadian Heritage Information Network/Réseau canadien d'information sur le patrimoine (CHIN). *Professional Resources* (1998). Includes publications, tools, links, and databases for documentation and other museum professional practice.
http://www.chin.gc.ca/Resources/e_resources.html

ICOM International Committee for Documentation (CIDOC). *Recent Museum Documentation Initiatives: Projects* (February 1998). News about and links to emerging standards, demonstration databases, and vocabulary applications in museums. Updated frequently.
http://www.cidoc.icom.org/stand3.htm

Museum Documentation Association Online. One of the best sources for information on museum documentation, including publications, Web tools, online fact sheets, and documentation demonstration projects.
http://www.open.gov.uk/ mdocassn/

Museums and the Web conference proceedings, ed. David Bearman and Jennifer Trant. Archives and Museum Informatics.
http://www.archimuse.com/pub.html#mw98

Pennell, Charley. *Cataloguer's Toolbox.* D.H. Hill Library, North Carolina State University (July 1998). An extensive compilation of links to bibliographic and archival cataloging tools, including visual materials.
http://www.mun.ca/library/cat/index.html

Sha, Vianne Tang. *Internet Library for Librarians* (June 1998). A Web guide with links to cataloging tools on the Web.
http://www.itcompany.com/inforetriever/

Visual Arts Data Service (VADS). VADS provides access to digital research data appropriate for re-use, by building an online archive of electronic resources.
http://vads.ahds.ac.uk

3. Selected Standards and Metadata Tools

DATA CONTENT/SYNTAX
Anglo-American Cataloguing Rules, 2nd ed. 1988 Revisions and 1993 Amendments. Electronic Version 1.0/CD-ROM format. Chicago: American Library Association, 1988, 1993.
http://www.ala.org/market/books/ technical.html

Betz, Elizabeth, comp. *Graphic Materials: Rules for Describing Original Items and Historic Collections.* Washington, DC: Library of Congress, 1982.
see http://lcweb.loc.gov/cds/train.html#gavm

Harvey, Kerridwen, and Patricia Young. *Data Content Standards: A Directory.* Ottawa: Canadian Heritage Information Network, 1994. Lists standards, organizations, and projects in English and French. Includes terminologies, dictionaries, and other sources.
see http://www.chin.gc.ca/Resources/Publications/ e_pdcsinfo.html

Hensen, Steven. *Archives, Personal Papers, and Manuscripts: A Cataloging Manual for Archival Repositories, Historical Societies, and Manuscript Libraries.* 2nd. ed. Chicago: Society of American Archivists, 1990.
see http://www.archivists.org/publications/catalog/description.html

Rules for Archival Description (RAD). Ottawa: Bureau of Canadian Archivists, 1990.

STRUCTURES AND FORMATS
Humanities Data Dictionary of the Canadian Heritage Information Network. Canadian Heritage Information Network, Museum Services, Documentation Research Group. Revision 3. Ottawa: Communications Canada, 1993.
see http://www.chin.gc.ca/Artefacts/RULH/e_hp_rulh.html

SPECTRUM: The UK Museum Documentation Standard. 2nd ed. 1997. SPECTRUM contains procedures for documenting objects and the processes they undergo as well as identifying and describing the information that needs to be recorded to support the procedures.
see http://www.open.gov.uk/mdocassn/spectrum.htm

Visual Resources Association, Data Standards Committee, *Core Categories for Visual Resources. Version 2.0* (October 1997). The VRA Core is intended as a guideline for describing visual documents depicting works of art, architecture, and artifacts from material culture. The VRA Core is the basis for the VISION testbed project.
http://www.oberlin.edu/~art/vra/dsc.html

Library of Congress. *MARC Standards.* A complete source for the MARC formats and information about MARC. The MARC formats are standards for the representation and communication of bibliographic and related information in machine-readable form.
http://lcweb.loc.gov/marc/

Getty Information Institute. *Categories for the Description of Works of Art* (CDWA). The *Categories*, which articulate an intellectual structure for the content of object and image descriptions, were developed by the Art Information Task Force (AITF), an initiative sponsored by the Getty Information Institute and the College Art Association (CAA).
http://www.ahip.getty.edu/index/cdwa.html

International Committee for Documentation (CIDOC) of the International Council of Museums (ICOM). *International Guidelines for Museum Object Information: The CIDOC Information Categories* (October 1995).
http://www.cidoc.icom.org/guide/

Library of Congress. *Encoded Archival Description* (EAD) (October 1997). The EAD Document Type Definition (DTD) is a standard for encoding archival finding aids using SGML. The standard is maintained in the Network Development and MARC Standards Office of the Library of Congress in partnership with the Society of American Archivists.
http://lcweb.loc.gov/ead/

Ahronheim, Judy. *Judy and Magda's List of Metadata Initiatives* (February 1997). Links to the major emerging metadata standards.
http://www-personal.umich.edu/~jaheim/alcts/bibacces.htm

Weibel, Stuart, and Eric Miller. *Dublin Core Metadata Element Set: Reference Description* (November 1997).
http://purl.org/metadata/dublin_core_elements

Network Development and MARC Standards Office. *Dublin Core/MARC/GILS Crosswalk*. A good illustration of what a crosswalk looks like. (April 1997).
http://www. loc.gov/marc/dccross.html

Attig, John C. *Dublin Core and the Cataloging Rules: Analysis Project*, ALCTS Committee on Cataloging: Description and Access Task Force on Metadata and the Cataloging Rules (April 1998). This site serves as the focus for an investigation and evaluation of "the proposed Dublin Metadata Core Element Set and its use as a source of information for cataloging." It includes a self-guided exercise using the Dublin Core data elements and a collection of sample Dublin Core records.
http://www.libraries.psu.edu/ iasweb/personal/jca/dublin/index.htm

Library of Congress. *Z39.50 Maintenance Agency*. ANSI/NISO Z39.50–1995 is a standard for use in searching and retrieving information over a computer network. Z39.50 enables uniform access to a large number of diverse and heterogeneous resources. When using a Z39.50 client one can provide users with a common interface for both the query and the search results, regardless of where the information came from.
http://lcweb.loc.gov/z3950/agency/

Day, Michael. *Metadata: Mapping between Metadata Formats* (December 1997). A list of crosswalks available on the Web.
http://www.ukoln.ac.uk/metadata/interoperability

4. Helpful Organizations

American Association for State and Local History (AASLH)
http://www.aaslh.org/

American Association of Museums (AAM)
http://www.aam-us.org

American Library Association (ALA)
http://www.ala.org

American Society for Information Science (ASIS)
http://www.asis.org/

Art Libraries Society of North America (ARLIS/NA)
http://www.lib.duke.edu/lilly/arlis

Association for Information Management (ASLIB)
http://www.aslib.co.uk/index.html

Association for Library Collections and Technical Services (ALCTS)
http://www.ala.org/alcts/

Canadian Heritage Information Network/Réseau canadien d'information sur le patrimoine (CHIN)
http://www/chin.gc.ca/

Computers and the History of Art (CHArt)
http://www.hart.bbk.ac.uk/chart/echart.html

Consortium for the Computer Interchange of Museum Information (CIMI)
http://www.cimi.org/

Getty Information Institute
http://www.gii.getty.edu

International Committee for Documentation/International Council of Museums (CIDOC)
http://www.cidoc.icom.org

International Federation of Library Associations and Institutions (IFLA)
http://www.nlc-bnc.ca/ifla

List of Professional Organizations in the Information Sciences (School of Library and Information Science at San Jose State University)
http://witloof.sjsu.edu/peo/allorgs/orgs.html

Museum Computer Network (MCN)
http://www.mcn.edu

Museum Documentation Association (MDA)
http://www.open.gov.uk/mdocassn/index.htm

National Center for Intelligent Information Retrieval at the University of Massachusetts at Amherst (CIIR)
http://ciir.cs.umass.edu/info/ciirinfo.html.

National Initiative for a Networked Cultural Heritage (NINCH)
http://www-ninch.cni.org

Online Computer Library Center (OCLC)
http://www.oclc.org

Research Libraries Group (RLG)
http://www.rlg.org

Society of American Archivists (SAA)
http://www.archivists.org

Visual Resources Association (VRA)
http://www.vra.oberlin.edu

World Wide Web Consortium (W3C)
http://www.w3.org/

5. Training Opportunities

American Association of Museums Professional Education Programs 1998. Continuing education courses for practitioners.
http://www.aam-us.org/profed.htm

Association for Library and Information Science Education Institutional Members. A list of graduate library schools whose professional degree programs have been approved by the American Library Association's Committee on Accreditation.
http://www.si.umich.edu/ALISE/schools.html

Cultural Resource Management Program at the University of Victoria. Provides professional development resources for people involved with museums, galleries, heritage agencies, and other cultural organizations throughout Canada and beyond. Some curriculum is available via distance learning courses.
http://WWW.UVCS.UVIC.CA/crmp/

ICOM/ICTOP International Committee for Training of Personnel. The mission of ICTOP is to encourage and promote relevant training to appropriate standards for all people working in museums throughout their careers, including students on museum-related pre-entry training programs.
http://www.maltwood.uvic.ca/maltwood-ictop.html

Museum Employment Research Center. *Organizations That Offer Museum Studies Courses.* An international list.
http://www.wyoming.com/~MERC/deeglis.html

Schankman, Larry. *Library and Information Science.* Main Library, Mansfield University. An extensive Web guide to resources related to the information professions.
http://www.clark.net/pub/lschank/web/library.html

Society of American Archivists Education. Includes information about archival education, including continuing education, in the United States and Canada.
http://www.archivists.org/education.html

Sundt, Christine. *Visual Resources Fundamentals.* Home page for a course taught at the University of Oregon.
http://oregon.uoregon.edu/~csundt/links.htm